ART AND DEVOTION IN SIENA AFTER 1350

D1295450

ART AND DEVOTION IN SIENA AFTER 1350

*Luca di Tommè and
Niccolò di Buonaccorso*

PIA PALLADINO

Timken Museum of Art
SAN DIEGO, CALIFORNIA
1997

PRINTED AND BOUND IN SINGAPORE

This catalogue accompanies the exhibition of the same name, at the Timken Museum of Art, December 12, 1997–April 12, 1998.

Cover: Luca di Tommè, Triptych: *The Trinity and the Crucifixion with Scenes from the Life of Christ,* ca. 1357–60. Pl. 4 (detail)
Frontispiece: Luca di Tommè, *Christ Blessing,* ca. 1350–55. Pl. 8 (detail)
Title page: Luca di Tommè, *The Trinity and the Crucifixion with Scenes from the Life of Christ,* ca. 1357–60. Pl. 4 (detail)
Page 8: Niccolò de Buonaccorso and Assistant, *Annunciation,* ca. 1380. Pl. 13a (detail)

Library of Congress Cataloging-in-Publication Data

Palladino, Pia.
 Art and devotion in Siena after 1350 : Luca di Tommè and Niccolò di Buonaccorso / Pia Palladino.
 p. cm.
 Catalog of an exhibition held at the Timken Museum of Art, Dec. 12, 1997–Apr. 12, 1998.
 Includes bibliographical references.
 ISBN 1-879067-03-X (soft : alk. paper)
 1. Luca di Tommè, 1330?–1389—Exhibitions. 2. Niccolò di Buonaccorso, d. 1388—Exhibitions. 3. Catholic Church and art—Italy—Siena—Exhibitions. 4. Painting, Gothic—Italy—Siena—Exhibitions. 5. Painting, Italian—Italy—Siena—Exhibitions. I. Luca, di Tommè, 1330?–1389. II. Niccolò di Buonaccorso, d. 1388. III. Timken Museum of Art. IV. Title.
ND623.L84A4 1998
759.5—dc21
 97-43426

CONTENTS

FOREWORD

Art and Devotion in Siena after 1350: Luca di Tommè and Niccolò di Buonaccorso is the sixth in an ongoing series of focus exhibitions designed to heighten understanding of important works of art in the Putnam Foundation Collection. When the series was inaugurated in the mid-1980s, it was assumed that the most feasible projects would involve our American and later European paintings. Due to the fragile nature of paintings on panel, organizing an exhibition around any of the Timken's early paintings seemed highly unlikely.

Dr. Laurence Kanter, curator of the Robert Lehman Collection at the Metropolitan Museum of Art, first proposed an exhibition devoted to fourteenth-century Sienese painting during a study visit to San Diego in conjunction with catalogue entries he was preparing for the Timken's collection catalogue. Larry convinced us that such an exhibition would indeed be possible. Dr. Pia Palladino, research associate at the Robert Lehman Collection and a specialist in Sienese painting, consented to serve as guest curator. Pia's efforts inform both the exhibition and the catalogue, and we thank her for the scholarship and thoroughness that underscore this publication. We are indebted to Pia for her perseverance and good humor.

Because wood is especially vulnerable to fluctuations in temperature and humidity, museums have traditionally been reluctant to lend paintings on panel. Technological advances, particularly with respect to custom packing containers that form their own microclimates, have seriously reduced the risk posed by long-distance travel. Thus it has become possible to obtain loans that only a decade ago might not have been considered. In this regard, we owe a great deal of gratitude to our lenders, who have recognized the scholarly endeavor that is the foundation of this enterprise and have thus generously acceded to our requests.

Exhibitions and catalogues—even modest ones—require the assistance of many individuals. We are grateful to the directors and trustees who approved the loan of these works, as well as to the curators, registrars, conservators, and photographic librarians at the lending institutions who assisted us with many details. Although it is not possible to thank everyone by name, we would like to extend our appreciation to the following people for their help and advice: Joseph Baillio, Sarah Bertalan, George Bisacca, Barbara Boehm, Keith Christiansen, Stephen Fliegel, Gaudenz Freuler, Rudolf Hiller von Gaertringen, Ivan Gaskell, Chiyo Ishikawa, Laurence Kanter, Ian Kennedy, Friedrich Kisters, Margaret Lawson, James McCredie, Patrice Marandel, Larry Nichols, and Eliot Rowlands. For their efforts on behalf of the exhibition and catalogue, we extend a special appreciation to Fronia W. Simpson for her editorial expertise, Marquand Books for catalogue design and production, and Gordon Chun for exhibition design.

Finally, a special appreciation goes to the Friends of the Timken Museum of Art for their generous support of the catalogue.

We are honored to be able to present this exhibition in San Diego and trust that the catalogue will be an informative and insightful addition to the study of fourteenth-century Sienese painting.

John A. Petersen
Director

Hal Fischer
Director of Exhibitions and Publications

LENDERS TO THE EXHIBITION

Fogg Art Museum, Harvard University Art Museums, Cambridge

Heinz Kisters Collection, Kreuzlingen

Robert Lehman Collection, The Metropolitan Museum of Art, New York

Los Angeles County Museum of Art

The Metropolitan Museum of Art, New York

North Carolina Museum of Art, Raleigh

Rijksmuseum, Amsterdam

San Diego Museum of Art

The Seattle Art Museum

Wadsworth Atheneum, Hartford

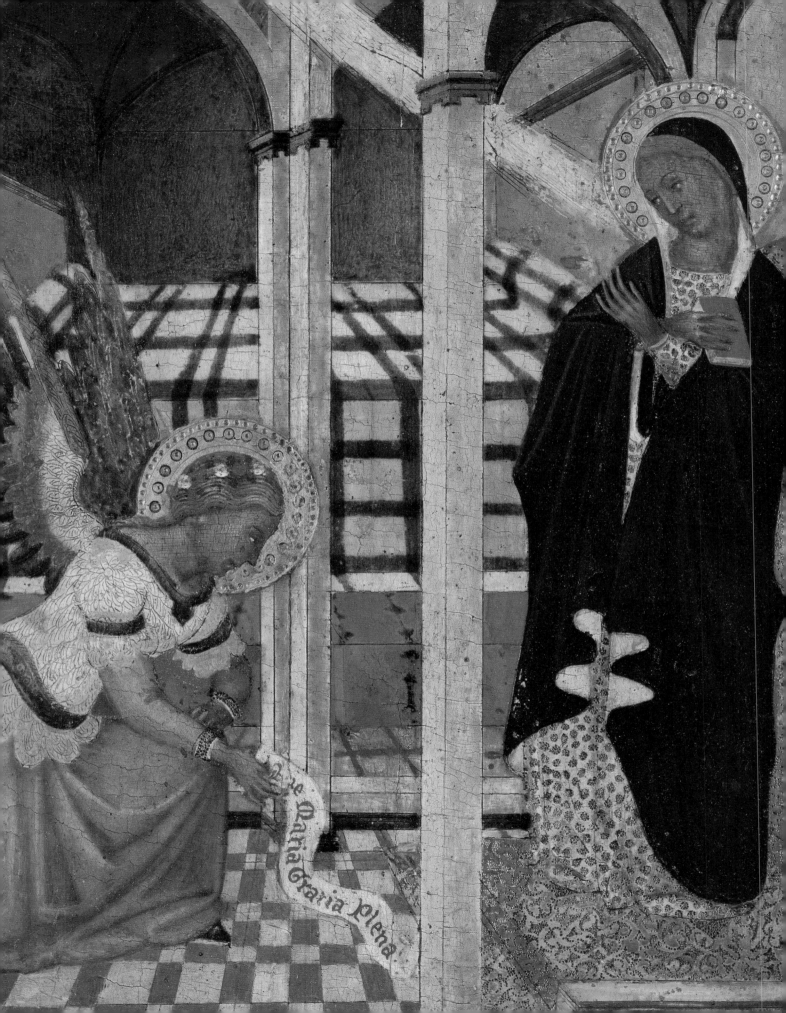

ART AND DEVOTION IN SIENA AFTER 1350

Luca di Tommè and Niccolò di Buonaccorso

INTRODUCTION

In 1951 one of the most noted authorities on late medieval and early Renaissance painting, Millard Meiss (1904–1975), published a book that would become a seminal study in the history of fourteenth-century Italian art: *Painting in Florence and Siena after the Black Death: The Arts, Religion, and Society in the Mid-Fourteenth Century*.[1] Starting with the premise that there is a vital connection between art and the society in which it is produced, Meiss set out to prove, through concrete examples, the existence of a direct relationship between the stylistic and formal developments in Tuscan art from about 1350 to 1379 and the collective cultural response to the devastating effects of the Black Death of 1348, the plague that swept across Europe and killed close to two-thirds of the Sienese population. In a fascinating interweaving of artistic connoisseurship and social history, Meiss argued that the post-plague generation of painters in Florence and Siena, reacting to a collective sense of pessimism, guilt, and religious penance brought on by the bankruptcies, famine, and war that accompanied the plague, rejected many of the spatial and formal accomplishments of their predecessors in favor of a style that was consciously archaic and antinaturalistic, concerned with the expression of the supernatural and the divine as opposed to the human and the earthly. Whereas in Florence the rejected model was that of Giotto, in Siena it was that of Duccio, Simone Martini, and the Lorenzetti brothers, Pietro and Ambrogio. According to Meiss, a new generation of Sienese painters, many of whom trained in the workshops of Simone Martini and the Lorenzetti, while copying their masters' models, transformed their vivid narrative style, defined by naturalistically rendered figures

moving in and out of clearly articulated spaces, into an essentially iconic, abstract idiom, consisting of shallow planes against which were placed static, withdrawn characters dominated by the rigidly frontal, and frequently disproportionately larger, representation of the divinity in one form or another. The result, in Meiss's view, was the visual expression of an angst-ridden world, concerned more than ever before with the exaltation of God and the Church, in a desperate quest for atonement and redemption in the afterlife.

Although Meiss's book was enormously influential, and is still used as a basic model for what may be termed a "sociocultural" history of art, the validity of his thesis has been challenged by historians and art historians alike.[2] To begin with, historians have questioned the accuracy of Meiss's assessment of the decisive impact of the Black Death of 1348, pointing out that the decade immediately following the crisis was marked in Siena, as in other Tuscan cities, by a period of gradual recovery and renewed optimism. Additionally, it has been noted that this was only the first of several outbreaks of pestilence that visited Tuscany regularly through the second half of the fourteenth century, beginning with a second serious epidemic in 1362–63, and that the recurrence of the calamity affected patterns of religious behavior more dramatically than did the plague itself. Art historians, for their part, have raised objections to Meiss's bold interpretation of the specific relationship between the style and iconography of paintings and a post-plague psychology, convincingly demonstrating that several of the works singled out by Meiss are in fact datable to the pre-1348 period. Additionally, Meiss's vision of a uniformly characterized post-plague style has

been rejected in favor of a more complex view of the second half of the century, in which artistic production is divided into different phases dominated by individual personalities and reflecting both the innovative and the conservative currents of the period.

Among recent discussions of Meiss's study, the most controversial arguments have been brought forward by those who accept the notion of a decisive change in the development of Sienese painting after the Black Death yet choose to minimize the relationship between medieval religious fervor and conservative aesthetic values, emphasizing instead the impact of new patterns of demand and production on the creation of works of art during this period. In an interesting comparative study of last wills drawn up across Tuscany and Umbria after the second outbreak of the plague, in 1362–63, the historian Samuel Cohn uses data gathered from testamentary bequests to chart the emergence of a new art market in Siena, defined by a marked increase in the demand for all types of artistic production, from the decoration of funerary chapels, including frescoes and altar furnishings, to painted tabernacles for private devotion.[3] According to Cohn, this new demand, datable to a period between 1364 and 1395, is related to the rise of a new category of individual patrons and donors from the artisan classes and the countryside, whose financial resources had dramatically improved after the Black Death and who gradually came to replace the powerful Communal authorities who had sponsored most artistic enterprises throughout the first half of the century. In response to the repeated trauma of the plague and the feeling of abandonment by relatives, friends, and churchmen we find described by contemporary chroniclers, these individuals, Cohn suggests, embraced a "cult of earthly memory" and sought to leave lasting, concrete memorials for themselves and their families through gifts to charitable institutions and the sponsoring of works of art. Additional data provided by Cohn also reveal that the increase in demand after 1362 was accompanied by a pronounced decrease in prices of works of art, which fell to one-fifth of their level before the Black Death. The explanations for this unusual phenomenon, Cohn argues, are to be found as much in the great preponderance of smaller works that survive from this period as in the changes in the nature of art production and workshop organization that have been outlined by recent art historians.

It has often been pointed out that the Black Death of 1348 did mark a hiatus in the artistic development of the city, if only because it carried off the two central figures in Sienese painting, Ambrogio and Pietro Lorenzetti, whose large workshops had dominated the Sienese art market since Simone Martini's departure for Avignon about 1340 (where he died in 1344). According to recent studies by the Norwegian art historian Erling Skaug,[4] after the Black Death and the death of the Lorenzetti, the nature of workshop organization appears to have changed. Those artists who survived the epidemic, most of them followers of Pietro and Ambrogio, now organized themselves in loosely formed *compagnie,* or partnerships, rather than heading individual workshops. Using the evidence provided by the reappearance of the same punch marks (the design that painters stamped into the gold ground of panel paintings with an engraved metal tool) in the work of different artists between 1350 and 1362–63, which would imply a mutual sharing of tools, Skaug proposes the existence of a "post-1350 compagnia" comprising the best Sienese artists of the day who pooled their technical resources to meet the new demand for paintings.

Although the changes in workshop practice outlined by Skaug appear to be limited in Siena to the years before the second outbreak of the plague in 1362–63 (after which individual workshops again constitute the norm), his study is nevertheless used by Cohn to support his general notion of art production after 1363. Skaug's technical observations, according to Cohn, confirm his own data regarding the increased demand and lowered prices of works of art after 1363, outlining a process of art production in Siena in the 1360s and 1370s analogous to the "cottage-industry" or "proto-industrial" manufacture of other commodities during the early modern period. As the pressure of increased demand and the reduced number of artists forced workshops to reorganize in large cooperatives, Cohn argues, "paintings became smaller, cheaper, and less sophisticated. . . . Like the manufacture of cotton cloth during the Industrial Revolution . . . these paintings cheapened, and the value that their commissions fetched stands as direct quantitative testimony to what art historians have judged qualitatively."[5]

The aim of the following pages is to reconsider the issues surrounding Meiss's thesis together with its most recent reinterpretations, through the production of two of

the principal protagonists of Sienese painting after 1350, Luca di Tommè and Niccolò di Buonaccorso. In the first case, the focus will be on Luca's early career and the nature of his collaboration with Niccolò di Ser Sozzo on the jointly signed and dated 1362 altarpiece now in the Siena Pinacoteca, which still remains a subject of scholarly debate. Is this collaboration on a major altarpiece a reflection of a master-pupil relationship, or is it in fact proof of that kind of professional association outlined by Skaug? In the second case, the emphasis will be on the production of small devotional panels by Niccolò di Buonaccorso, one of the most accomplished yet least known artists of this period, whose interest in the depiction of intimate and believable domestic settings, in accord with the most innovative Sienese narrative tradition, would appear to contradict both Meiss's theory and Cohn's conclusions. The repetition of Niccolò's models in the work of anonymous artists such as the Master of Panzano, also represented in the exhibition, will be explored in relation to the phenomenon of "proto-industrial" mass production described by Cohn. May it not be argued that the stylistic uniformity noticeable in the art of this period is in fact restricted to the production of minor artists and is, therefore, no different from that observable in the vast output of anonymous and mostly provincial imitators of Duccio in the first quarter of the fourteenth century?

Whether or not such questions can ever be fully answered, what emerges from the study of these two painters is a complex picture of Sienese painting in the second half of the fourteenth century that cannot be fitted into any single pattern of cause-and-effect development, either spiritual or socioeconomic. Instead, their works reveal the birth of that strongly conservative strain that will characterize Sienese painting well into the sixteenth century, as the shadow of the great masters of the Golden Age of Sienese painting—Duccio, Simone Martini, and the Lorenzetti brothers—increasingly dominated the choices of patrons and artists. But although we do notice in the production of this period a pronounced repetition of motifs and compositional formulae derived from these earlier masters, especially from Ambrogio and Pietro Lorenzetti, we cannot speak of a uniformly characterized post-plague style, defined by a mechanical rigidity of forms and expression. As the works selected for this exhibition ultimately reveal, Luca di Tommè and Niccolò di Buonaccorso stand as concrete

examples of the ability of the best post-plague painters to draw inspiration from the models of past decades and produce images that—although perhaps not as innovative as their prototypes—are nonetheless characterized by the same spontaneous narrative vivacity, harmonious balance of colors, and engaging human interest.

LUCA DI TOMMÈ

Defined by Meiss as "the subtlest of Sienese painters of the 'sixties and 'seventies,"[6] Luca di Tommè was, with Bartolo di Fredi, one of the two dominant artistic personalities in Siena in the second half of the fourteenth century. Judging from the large number of his surviving works, he was a highly successful painter and the head of a busy workshop, specializing in altarpieces incorporating large-scale images of the Virgin and Child with saints, executed for a broad market that included not only Siena and the surrounding areas but also localities in Umbria and the Marches.

Although the dates of Luca's birth and death are not known, a fairly large body of surviving documents dated between 1357 and 1390 does exist that records his activity both as a painter and in public office. The first references to him occur in a series of payments from the authorities of Siena cathedral, first for minor decorative work in 1357 and then for repainting a fresco of the Madonna and Child on the facade of the cathedral in 1358.[7] Four years later, in 1362, Luca and two older and more established Sienese masters, Bartolomeo Bulgarini and Jacopo di Mino del Pellicciaio—both mentioned as the best Sienese painters of the time in a Pistoiese document of 1349[8]—were paid by the cathedral authorities for their advice regarding the transferral of Duccio's *Maestà* from the high altar, a circumstance that would seem to indicate that by this date Luca already enjoyed a substantial reputation. That same year Luca collaborated with another established Sienese master, Niccolò di Ser Sozzo, on the large altarpiece of the Madonna and Child with saints now in the Pinacoteca Nazionale, Siena (fig. 1).

In 1363 Luca's name appears with that of other painters in a register of all the masters then active in the various Sienese guilds. Possibly datable also to 1363 is a commission awarded to the artist by the Commune for a thus far unidentified painting of St. Paul commemorating the Sienese victory at the Battle of Valdichiana, in October of that year, over the Compagnia del Cappello, an army of

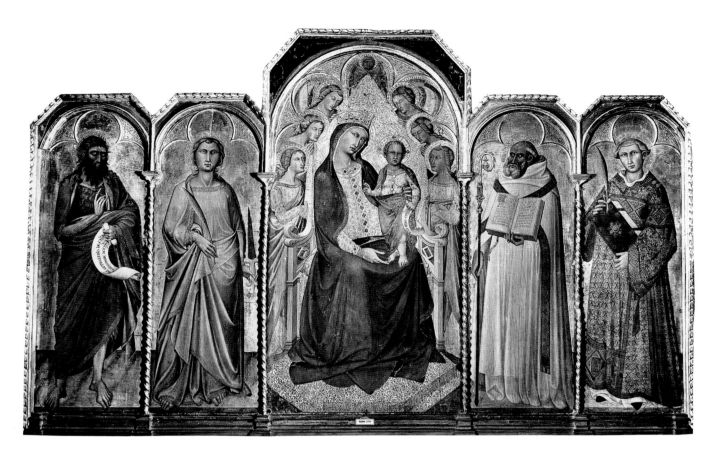

1. Niccolò di Ser Sozzo and Luca di Tommè, *Virgin and Child Enthroned with Sts. John the Baptist, Thomas, Benedict, and Stephen* (Umiliati polyptych). Pinacoteca Nazionale, Siena. Photo courtesy of Alinari/Art Resource, New York

mercenary soldiers that had been marauding through the countryside. Although this work is usually dated to 1374 on the basis of the one surviving record of payment for it, the wording of this document, stating that "the altarpiece was made in honor and reverence to St. Paul [named the patron of the expedition] at the time that the Commune defeated the Compagnia del Cappello,"[9] would seem to hint that even if the execution of the panel was protracted over a number of years, the commission was actually given to the artist at the same time that the Commune entrusted Lippo Vanni to paint the still-extant fresco commemorating the same battle in the Council Hall of the Palazzo Pubblico, which is signed and dated 1363.[10] Besides providing further confirmation of his distinction, such a conclusion would also imply that at least by 1363 Luca was established as an independent artist and running his own workshop.

Luca's career after these earliest documented works is marked by three signed and dated altarpieces now in the Museo Nazionale di San Martino, Pisa (1366), the Pinacoteca Nazionale, Siena (1367), and the Museo Civico, Rieti (1370), which define the full maturity of the artist's idiom. His success as an artist and his position as a leading citizen of Siena during these years are attested by a series of documents from the late 1360s into the early 1380s that reflect his increasing involvement in governmental affairs.[11] The first such notice dates from 1368 and coincides with the installation, after a series of crises, of a new government in Siena, the so-called Riformatori, that opened the doors to new men of the artisan classes and from the countryside; in this year Luca's name appears as a representative of his district, the Terzo di Camollia, to the General Council of the majority party. In 1373 and again in 1379 he is recorded as representing his district (on the second occasion it is the

Terzo di Città) as one of the "twenty-four councillors for the protection of the public good." And from 1383, providing a clear indication of his financial prosperity, comes the notice of his appointment to the post of Provveditore, or leading official of the Biccherna, Siena's main financial office. Elected by the General Council for a six-month term, the four holders of this position were usually among the wealthiest citizens of Siena, who in times of economic crisis had at their disposal enough liquid capital to advance money to the treasury, until cash from its major sources of income became available.[12] Final confirmation of Luca's status and his relative seniority among Sienese painters of this period is the appearance of his signature in third position, after the older Lippo Vanni and Jacopo di Mino del Pellicciaio,[13] on the list of painters appended, sometime between 1378 and 1386, to the 1356 statutes of the painters' guild.[14]

Between 1383 and 1388, when he was one of the artisans selected to judge a competition for the design of the new choir stalls for Siena cathedral, Luca's name disappears from the surviving documents. Significantly, in 1384 the Sienese government underwent another major political upheaval as the "Riformatori," the party under which Luca had served in public office, was toppled, and, according to the sixteenth-century Sienese chronicler Orlando Malavolti, at least four thousand of its members, most of them artisans, were forced into exile.[15] It is worth speculating whether Luca was also one of the artists forced to leave his native city and if the high incidence of outside commissions received by his workshop during this period might in fact betray his new situation. His name does appear again, however, in Siena's new painters' roll of 1389, this time after only Jacopo di Mino del Pellicciaio. That same year, Luca, together with Bartolo di Fredi and his son Andrea di Bartolo, was entrusted with the commission for an altarpiece for the shoemakers' confraternity in Siena cathedral.

The last preserved notice of the artist is in the will drawn up in May 1390 by the Sienese merchant Marco di Bindi Gini, who provided funds for an altarpiece to be painted by Luca, for his newly built chapel in San Francesco. Since Luca's name does not reappear with that of other artists in the next list of the painters' guild, apparently added to the 1389 register sometime between this date and 1414, it is generally assumed that he must have died

shortly after 1390[16]—if not in the plague that once again swept across Siena that very same year.[17]

The most complicated issue raised by a consideration of Luca di Tommè's long and prolific career involves his earliest production, beginning with the dated 1362 polyptych in the Pinacoteca Nazionale, Siena, Luca's first signed work, executed jointly with the Sienese painter and miniaturist Niccolò di Ser Sozzo (fig. 1). One of the largest and most important altarpieces produced in Siena in the second half of the fourteenth century, it shows the Virgin and Child Enthroned, flanked by full-length figures of Sts. John the Baptist, Thomas, Benedict, and Stephen. The predella, dispersed during the nineteenth century and identified by Federico Zeri in 1958, consists of four panels with scenes from the Life of St. Thomas, now in a private collection, and a *Crucifixion* in the Pinacoteca Vaticana, Rome (fig. 2a–e).[18] Although there is no document recording the commission for the altarpiece, the emphasis given to St. Thomas in the predella scenes and his location in the position of honor to the Virgin's right among the main panels, as well as the inclusion, opposite him, of St. Benedict, have led to the plausible suggestion that it was produced for the main altar of the church of San Tommaso in Siena, which was given to the Umiliati, a reformed branch of the Benedictine order, in 1293.[19]

Ever since Cesare Brandi first published in 1932 the following inscription found on the decorative framing beneath the Virgin and Child, "NICCHOLAUS SER SOCCII ET LUCAS TOMAS DE SENIS HOC OPUS PINSERUNT ANNI MCCCLXII" (Niccolò de Ser Sozzo and Luca di Tommè of Siena painted this work in the year 1362), the attribution of the various parts of the Umiliati polyptych and the nature of the two artists' collaboration have been sources of scholarly debate. Most recent opinion is divided between those who, following Brandi, emphasize Niccolò's dominant role in the conception of the altarpiece, restricting Luca's participation to the execution, over the older master's design, of the predella and one or more of the lateral figures in the main panels;[20] and those who would rather follow Millard Meiss in crediting Luca with a greater responsibility in the design as well as execution of the altarpiece, viewed as the result of a collaborative effort among equals, rather than as the product of a master-pupil

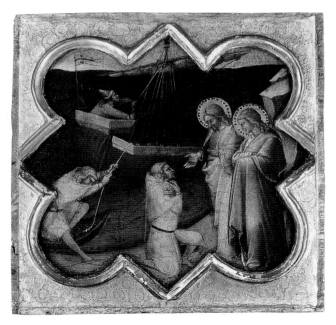

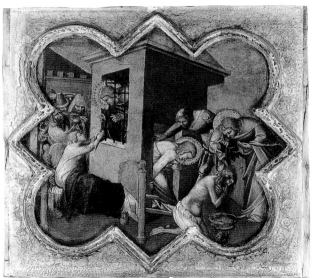

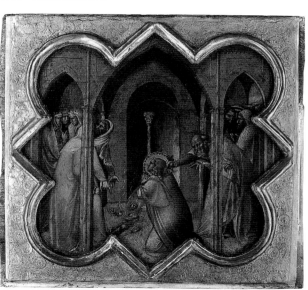

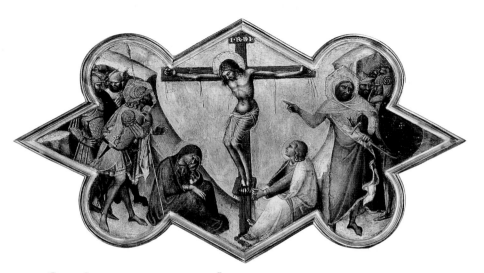

2. Luca di Tommè, predella of the Umiliati polyptych:

2a (upper left). *Christ Ordering St. Thomas to Convert India.* Private collection

2b (upper right). *Miracle of the Punishment of the Cruel Servant at the Wedding Banquet of a King's Daughter.* Private collection

2c (lower left). *St. Thomas Resuscitating the King's Brother while in Prison; Release of St. Thomas; Baptism of the King.* Private collection

2d (lower right). *Execution of St. Thomas.* Private collection

2e (bottom). *Crucifixion.* Pinacoteca Vaticana, Rome

3. Niccolò di Ser Sozzo, *Assumption of the Virgin.* Archivio di Stato, Siena. Photo courtesy of the Institute of Fine Arts, New York University, Richard Offner Collection

relationship.[21] At the root of these divergent opinions are, in the first place, a still vague view of the exact nature of artistic collaboration and workshop practices during this period; and, in the second place, the lack of a clear consensus regarding the stylistic development of Niccolò di Ser Sozzo, one of the most enigmatic personalities in Sienese painting of the middle of the fourteenth century.

Formerly known as Niccolò di Ser Sozzo "Tegliacci" on the basis of a mistaken association with the homonymous Sienese nobleman Ser Sozzo di Francesco Tegliacci,[22] Niccolò was the preeminent manuscript illuminator in mid-fourteenth-century Siena. He was first identified on the basis of the signature "NICHOLAUS SER SOZZI DE SENIS ME PINXIT" (Niccolò di Ser Sozzo of Siena painted me) below a large illumination of the Assumption in the so-called Caleffo dell'Assunta, a register of Sienese public documents transcribed between 1334 and 1336, in the Archivio di Stato, Siena (fig. 3).[23] This work, considered one of the masterpieces of early Sienese painting, has provided the basis for the attribution of a significantly large body of manuscript illuminations, including the two

cuttings in the present exhibition (pls. 1, 2), that would appear to reflect the artist's position at the head of one of the most active workshops in Siena in the production of illuminated books, as well as panel paintings. Despite the fairly large body of surviving works, however, very little is known about Niccolò's artistic personality and the various phases of his development. Aside from the 1362 altarpiece, none of the illuminations and paintings that can be securely attributed to him are dated, and the few known documents mention, not a work of art or commission, but his various roles in public office. The only notices of his activity as a painter are in the earliest reference to him, in the 1348 loan records of the Commune, where he is listed as "Nicolò di Ser Sozo dipentore"; and in the 1363 register of masters enrolled in the various Sienese guilds, where his name appears among the painters, shortly after that of Luca di Tommè.[24] That same year, on June 15, 1363, his death is recorded in the Necrologio of San Domenico, possibly among the victims of the second outbreak of the plague.[25]

The problems raised by the lack of any fixed points in Niccolò's career aside from the controversial 1362

polyptych are reflected in the debate over the dating of his only other signed work, the *Assumption* miniature in the Caleffo dell'Assunta. Generally considered Niccolò's first mature effort, the execution of this work has been placed by some authors as early as 1336–38, that is, contemporary to or slightly after the completion of the Caleffo text,[26] and by others to about 1348–50, about the time that the artist's name first appears in the documents.[27] These views have affected the perception of Niccolò's stylistic development, considered in the first instance as departing from an earliest phase datable to about 1330 and in the second instance as beginning no sooner than at least a decade later.

Efforts to discern an initial phase of stylistic development in Niccolò's manuscript production as early as the fourth decade of the fourteenth century are not supported by close examination of the illuminations themselves. These reveal a general uniformity in concept and execution in which the dominating influence is that of Pietro Lorenzetti's mature style, as represented by dated works

such as the 1340 *Virgin and Child with Saints* in the Uffizi or the 1342 *Birth of the Virgin* in the Museo dell'Opera del Duomo, Siena (fig. 4). The particular relevance of this specific phase of Pietro's production was correctly pointed out by Giulietta Chelazzi Dini in her discussion of Niccolò's illuminations in two Graduals from the cathedral of San Gimignano (Museo Diocesano d'Arte Sacra; Cod. LXVIII.I, LXVIII.2; fig. 5), and of two cuttings from the Wildenstein collection, Paris, where we find compositional motifs directly derived from Pietro's *Birth of the Virgin,* such as the detail of the nurse bathing the child in the Wildenstein cutting, as well as similar spatial and decorative concerns.[28]

Less convincing, however, was Chelazzi Dini's perception of a change between these illuminations and the Caleffo *Assumption,* for which she favored an earlier date of about 1338. These works are in effect virtually identical in concept and execution, in both the handling of the figures and the suggestion of space. In both cases we find the same

4. Pietro Lorenzetti, *Birth of the Virgin.* Museo dell'Opera del Duomo, Siena

generalized, broadly modeled figural types with rounded heads framed by neatly curled locks of hair and large features cast in soft shadow; their bodies covered by ample draperies that either are pulled tightly across to reveal movement or shape or fall in sweeping linear rhythms to create elegant, decorative patterns. Additionally, if it was Pietro Lorenzetti, as Chelazzi Dini suggested, who directly inspired Niccolò's spatial concerns in the San Gimignano Graduals (fig. 5), where the figure of St. Gimignano is depicted firmly seated on a solid, geometrically articulated throne surrounded by angels in a clearly visualized setting, the same influence is no less pronounced in the Caleffo *Assumption*. For here too, despite the iconic nature of the motif of the Virgin in a mandorla, Niccolò manages to convey an impression of depth both by the lunging figure of St. Thomas reaching across the marbleized floor to reach for the girdle and by the depiction of the mandorla itself, shown, not as a metaphysical two-dimensional shape, but as an actual three-dimensional object viewed in perspective. Seated naturalistically inside the mandorla, as if on a real throne, is the Virgin, represented, not in the usual, starkly frontal position, but turned slightly in three-quarter profile. The same spatial illusion and figural types that characterize the San Gimignano Graduals and the Caleffo *Assumption* are also found in the two cuttings by Niccolò in this exhibition: a large Antiphonary leaf with the Assumption of the Virgin in an initial *V,* from the Metropolitan Museum of Art, New York (pl. 1);[29] and a small cutting, also excised from an Antiphonary, with the Ascension in an initial *V,* from the Robert Lehman Collection in the Metropolitan Museum of Art (pl. 2).[30]

The predominance of formal and decorative motifs derived from Pietro Lorenzetti's mature works apparent throughout Niccolò's manuscript production suggests that none of the illuminations thus far associated with him may in fact be dated before the first half of the 1340s. Additionally, they indicate that the artist might actually have received his early formation in the workshop of the Lorenzetti. In support of such an assumption, Erling Skaug has recently observed that at least one-fourth of all the punch marks found in Niccolò's paintings are clearly derived, and probably inherited, from the Lorenzetti workshop.[31]

Niccolò's transformation of Lorenzettian models into a highly refined but essentially formulaic personal idiom makes it difficult to establish a chronological framework

5. Niccolò di Ser Sozzo, *St. Gimignano Enthroned.* Museo Diocesano d'Arte Sacra, San Gimignano (Cod. LXVIII.1, fol. 22r). Photo courtesy of the Institute of Fine Arts, New York University, Richard Offner Collection, and Alinari/ Art Resource, New York

Pl. 1 NICCOLÒ DI SER SOZZO

Assumption of the Virgin in an Initial "V" (page from an Antiphonary), ca. 1342–50

Tempera, gold, and ink on vellum, 57.5 × 40.3 cm (22⅝ × 15⅞ in.)

The Metropolitan Museum of Art, New York, Gift of Louis L. Lorillard,

1896. (96.32.12)

Pl. 2 NICCOLÒ DI SER SOZZO
Ascension in an Initial "V" (cutting from an Antiphonary), ca. 1342–50
Tempera, gold, and ink on vellum, 15.5 × 16.0 cm (6⅛ × 6¼ in.)
The Metropolitan Museum of Art, New York, Robert Lehman Collection.
(1975.1.2472)

6. Niccolò di Ser Sozzo and assistant, *Assumption of the Virgin with Sts. Thomas, Benedict, Catherine of Alexandria, and Bartholomew* (Monteoliveto altarpiece). Museo Civico Medievale, San Gimignano. Photo courtesy of Alinari/Art Resource, New York

7. Niccolò di Ser Sozzo, *Virgin and Child*. Galleria degli Uffizi, Florence. Photo courtesy of the Institute of Fine Arts, New York University, Richard Offner Collection

for the execution of his illuminations, beyond a *post quem* date of 1340–42. On the other hand, a comparison of Niccolò's manuscript production with his works on panel, beginning with the Monteoliveto altarpiece (Museo Civico Medievale, San Gimignano), unanimously attributed to the artist and datable to the mid- or late 1340s,[32] reveals a significant transformation in the artist's style, characterized by a hardening of forms through dark incisive outlines and a pronounced narrowing of facial features (fig. 6). This change in direction, more pronounced in other, slightly later paintings such as the *Virgin and Child* in the Hermitage, St. Petersburg,[33] or the *Virgin and Child* from the Augustinian monastery of Sant'Antonio al Bosco, now in the Uffizi, Florence (fig. 7),[34] would appear to coincide with a new phase in Niccolò's career, marked by an increased production of works on panel to the exclusion of manuscript illumination, and involving the increased participation of assistants.[35]

The issue of workshop intervention in Niccolò's panel paintings was first pointed out by Sherwood Fehm, who identified the hand of an assistant in the execution of the figures of Sts. Thomas and Bartholomew in the outermost panels of the Monteoliveto altarpiece.[36] The tensely exaggerated forms of this second artist, who must have been a prominent member of Niccolò's shop, were also recognized by Fehm in a series of panels for which the attribution has traditionally shifted between Niccolò and Luca di Tommè:

a dismembered altarpiece representing St. John the Baptist (Trinity College, Hartford, Conn.; fig. 8), Peter (Courtauld Institute Galleries, London), and St. Catherine (formerly Roerich collection, New York); an *Annunciation* in the Palazzo Pubblico, Siena (perhaps part of the same polyptych?; fig. 9);[37] and a triptych formerly in a private collection, Siena.[38] Following Fehm, Laurence Kanter has recently identified the same hand in the two lateral panels with standing saints in a polyptych designed by Niccolò in the Museum of Fine Arts, Boston (fig. 10), and in a large *Crucifix* in the church of Santo Spirito, Siena (fig. 11), both of which had also been previously attributed either to Niccolò himself or to Luca.[39] To this list may also be added a little known panel with St. Michael and the dragon in the National Museum of Western Art, Tokyo (fig. 12), whose attribution has otherwise shifted between "Barna da Siena" and an improbable follower of Simone Martini identified as "Master of the Rebel Angels."[40]

Could this assistant of Niccolò di Ser Sozzo have been the young Luca di Tommè? Do the attributional debates still wandering back and forth between the two artists[41] imply that one necessarily developed as a student of the other? In the following pages it will be suggested that close examination of Luca's career does in fact reveal points of contact between him and Niccolò which precede their collaboration on the 1362 altarpiece, although this does not necessarily imply a master-pupil relationship, for the overriding influence on the development of Luca's idiom, as first pointed out by Frederick Mason Perkins and emphasized by Fehm,[42] was less that of Niccolò di Ser Sozzo than that of Pietro Lorenzetti, from whom Luca derived above all his clear sense of space and composition, as well as his color and figural style.

A crucial work in the assessment of Luca's independent personality prior to the 1362 altarpiece is to be found in the 1357 Gabella cover (one of the account books of

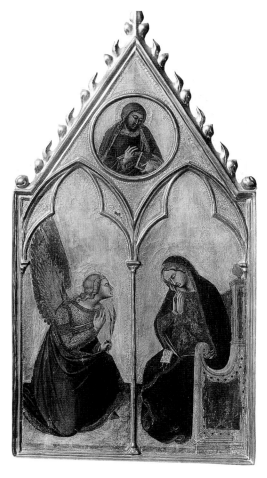

8 (left). Assistant of Niccolò di Ser Sozzo, *St. John the Baptist.* Trinity College, Hartford, Conn. Photo courtesy of the Institute of Fine Arts, New York University, Richard Offner Collection

9 (right). Assistant of Niccolò di Ser Sozzo, *Annunciation.* Museo Civico di Palazzo Pubblico, Siena. Photo courtesy of the Institute of Fine Arts, New York University, Richard Offner Collection

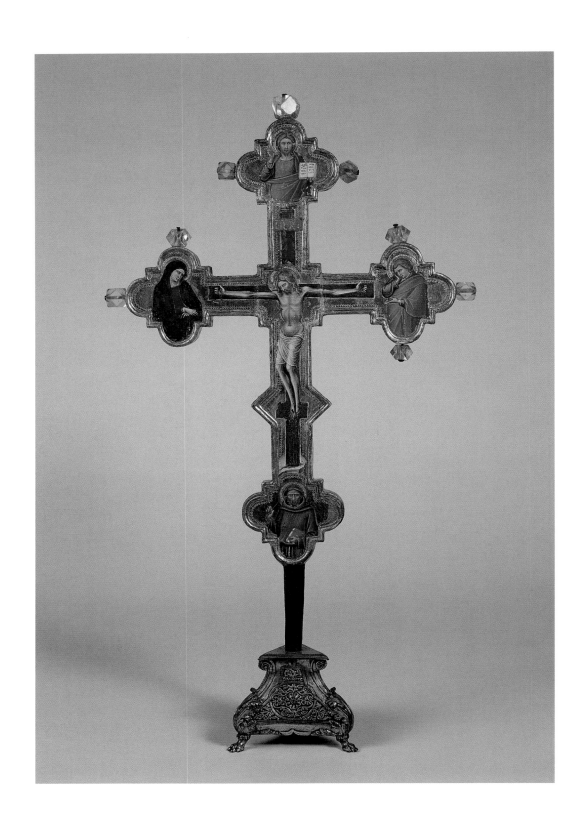

Pl. 3a LUCA DI TOMMÈ

Processional Crucifix: recto, *Crucified Christ between the Virgin and
St. John the Evangelist, Christ Blessing, and St. Francis,* ca. 1357–60

Tempera, silver, and gold leaf on wood with rock crystal,
43.8 × 30.8 cm (17¼ × 12⅛ in.)

Courtesy of the Fogg Art Museum, Harvard University Art Museums,
Cambridge, Bequest of Mrs. Jesse Isidor Straus, 1970.59

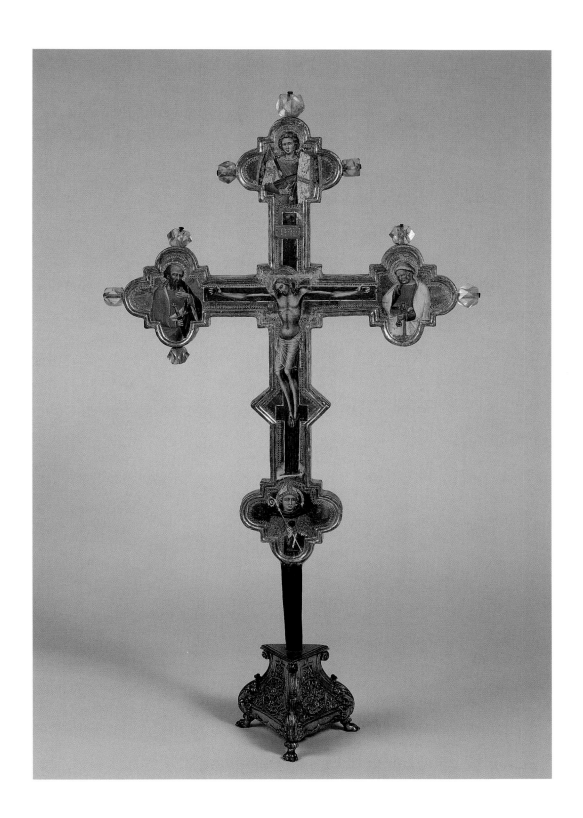

Pl. 3b LUCA DI TOMMÈ
Processional Crucifix: verso, *Crucified Christ between Sts. Paul, Peter,*
Michael, and Louis of Toulouse, ca. 1357–60
Tempera, silver, and gold leaf on wood with rock crystal,
43.8 × 30.8 cm (17¼ × 12⅛ in.)
Courtesy of the Fogg Art Museum, Harvard University Art Museums,
Cambridge, Bequest of Mrs. Jesse Isidor Straus, 1970.59

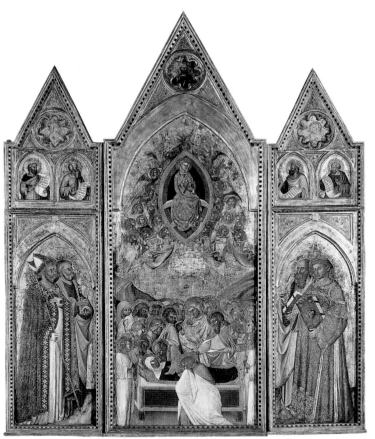

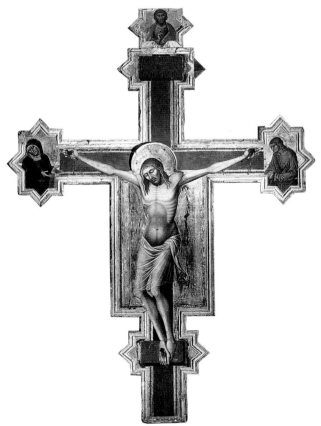

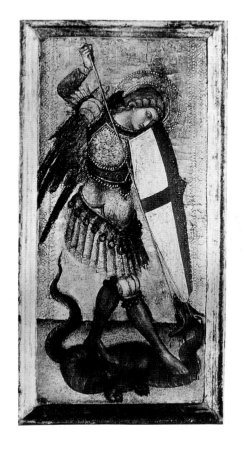

10 (above left). Niccolò di Ser Sozzo and assistant, *Assumption of the Virgin with Sts. Augustine and Peter, John the Evangelist, and Unidentified Deacon Saint.* Museum of Fine Arts, Boston, Gift of Martin Brimmer

11 (above right). Assistant of Niccolò di Ser Sozzo, *Crucifix.* Church of Santo Spirito, Siena. Photo courtesy of Alinari/Art Resource, New York

12 (left). Assistant of Niccolò di Ser Sozzo, *St. Michael and the Dragon.* National Museum of Western Art, Tokyo. Photo courtesy of the Institute of Fine Arts, New York University, Richard Offner Collection

13. Luca di Tommè, Gabella cover with *Presentation in the Temple.* Archivio di Stato, Siena

14. Taddeo Gaddi, *Presentation of the Christ Child in the Temple.* Galleria dell'Accademia, Florence. Photo courtesy of Alinari/Art Resource, New York

Siena's main financial office) in the Archivio di Stato, Siena, depicting the Presentation in the Temple (fig. 13). First attributed to the artist by Chelazzi Dini, this panel represents the only fixed point in Luca's career before his collaboration with Niccolò di Ser Sozzo.[43] Though frequently overlooked by subsequent scholars,[44] it offers a clear indication of Luca's active role in the design as well as execution of the 1362 predella, where we find similar figural types and spatial concerns, especially in the scene of the Execution of St. Thomas (fig. 2d), that are ultimately derived from the example of Pietro Lorenzetti. Indeed, it is the determining impact of Pietro's art on Luca's formation that is immediately discernible in the *Presentation in the Temple,* whose composition is a virtual repetition, in reverse, of the same subject in a small panel by Pietro in the Mimara Museum in Zagreb, generally dated between 1335 and 1340.[45] Pietro's lunging, massive figure of the Virgin reaching forward with extended arms to grasp the Christ Child finds an exact counterpart in Luca's panel, as do the receding view through a vaulted interior behind the priest and such details as the engraved decoration on the face of the altar. The only change introduced by Luca is

in the gesture of the Christ Child, shown turned away from the priest to reach anxiously toward his mother; an intimately familiar detail of human emotion, derived from one of Giotto's closest followers, Taddeo Gaddi (fig. 14), that conspicuously contradicts Meiss's notion of the "ritualistic" character of post-plague imagery in opposition to the narrative and naturalistic concerns of previous decades.[46]

The coincidence of the 1357 Gabella cover with the first record of Luca's name in the documents for Siena cathedral and the fact that such a commission would not have been entrusted by the Sienese Commune to a relatively unknown artist suggest that by this date he was a fully established independent master. Luca's subsequent production, leading to the 1362 altarpiece, reflects the progressive development of his style as defined by the *Presentation in the Temple,* toward an increasingly refined and expressive idiom that reaches its apex in works such as the processional *Crucifix* from the Fogg Art Museum, in Cambridge (pl. 3a, b), and in the portable triptych from the Timken Museum of Art (pl. 4).

The double-faced *Crucifix* in the Fogg Art Museum is one of the rare surviving examples of a once-common type

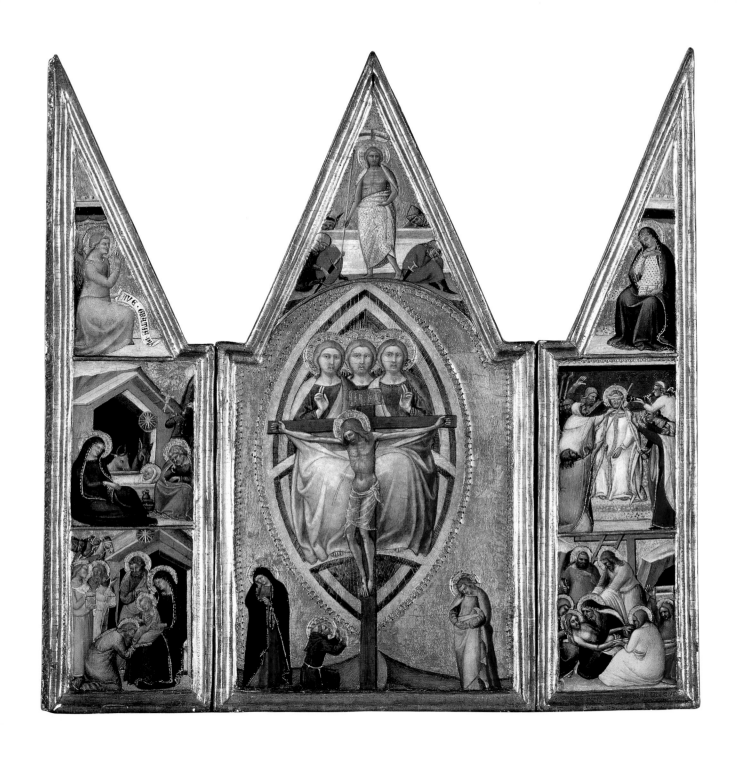

Pl. 4 LUCA DI TOMMÈ
Triptych: *The Trinity and the Crucifixion with Scenes from the
Life of Christ,* ca. 1357–60
Tempera and gold on wood, 56.5 × 53.4 cm (22¼ × 21 in.)
Timken Museum of Art, San Diego, 1967.3

of liturgical object used in all major religious processions. Although it is now inserted in a modern base, it originally would have been fixed to a long pole carried by a member of the church or religious confraternity that commissioned it. Intended to be seen on both sides, it shows on the recto the Crucified Christ between the Virgin and St. John the Evangelist, with Christ Blessing above and St. Francis below; and in the corresponding positions on the verso the Crucified Christ between Sts. Paul, Peter, Michael, and Louis of Toulouse. The presence of Sts. Francis and Louis of Toulouse suggests that the *Crucifix* was commissioned by a Franciscan community in Siena or its environs.

Perhaps datable slightly later than the 1357 Gabella cover, the *Crucifix* reflects Luca's continuing incorporation of Lorenzettian motifs into his own style, defined by an increasing elongation of forms and incisive use of line, as well as a darkening of the palette. The figure of the Cruci-fied Christ itself, as pointed out by Fehm,[47] appears mod-eled directly on Lorenzettian prototypes such as the large *Crucifix* in the Museo Diocesano, in Cortona (fig. 15), from which Luca derived such telling details as the virtu-ally impossible stretch of the arms along the entire horizon-tal axis of the cross, as well as the folds of the diaphanous draperies. The massive build of the Cortona Christ, how-ever, has been transformed by Luca through an exagger-ated elongation of the limbs and heightened chiaroscuro, which, while resulting in a less naturalistic figure, accentu-ate its expressive content. The meticulous definition of the features and the attention to individual details and surface decorative effects, moreover, lend the object as a whole a lively quality that goes beyond the iconic character of the representation, making this one of Luca's finest creations.

If the Fogg *Crucifix* reflects Luca's successful adapta-tion of formal motifs derived from Pietro, his complete mastery of Lorenzettian compositional devices and spatial organization is manifest in another remarkable work from this period, the portable altarpiece from the Timken Museum of Art. Characterized by the same precious refinement that distinguishes the Fogg *Crucifix,* this small work simultaneously anticipates the lively feeling for narra-tive that marks Luca's later production and confirms his much-debated authorship of the predella scenes in the 1362 altarpiece.

The size and structure of the Timken triptych, with a wide central panel flanked by narrower wings that would

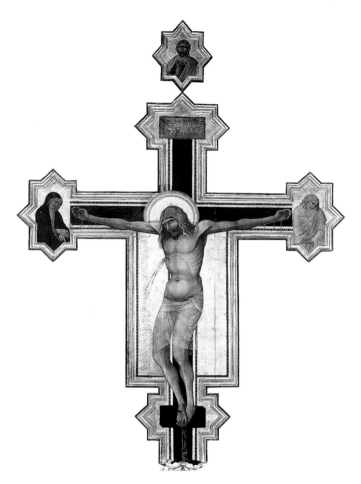

15. Pietro Lorenzetti, *Crucifix.* Museo Diocesano, Cortona. Photo courtesy of the Institute of Fine Arts, New York University, Richard Offner Collection

have folded over it, are typical of the small portable altar-pieces that were common throughout the Middle Ages as objects of private devotion. Part of the furnishings of a small domestic altar, it would have been kept open by its owner for the duration of special religious holidays, but otherwise left closed except for the hours of prayer. The central panel of the triptych, which was probably also commissioned by a member of a Franciscan community— perhaps the same one that commissioned the Cambridge *Crucifix*—shows the small figure of St. Francis, flanked by the mourning Virgin and St. John the Evangelist, kneeling at the foot of a cross behind which rises a large representa-tion of the Trinity in a mandorla. In the pinnacle above is the Resurrected Christ standing triumphantly before his empty tomb, at each corner of which lies a sleeping sol-dier, two in front and two partially visible on the other side.

The two wings are each divided into three scenes from the Life of Christ. In the pinnacle of the left wing is the Angel of the Annunciation; below it are the Nativity and the Adoration of the Magi. In the corresponding compartments of the right wing are the seated Virgin Annunciate, the Mocking of Christ, and the Lamentation.

While the inclusion of separate narrative episodes related to the Life of Christ in the lateral panels of the Timken triptych recalls earlier objects of this kind produced in Duccio's workshop or by his followers,[48] the image of the Trinity and Crucifixion in the central panel, which usually contains a Maestà or a Crucifixion alone, is virtually without precedent in Siena or elsewhere and has been an object of continuous scholarly discussion. In a chapter entitled "The Exaltation of God, the Church, and the Priest," Meiss was the first author to discuss the Timken triptych in terms of the uniqueness of its central composition, in which he perceived a fundamental shift in thought that he traced to post-plague spiritual values.[49] Whereas in earlier representations the concept of the Holy Trinity (God the Father, the Son, and the Holy Spirit) was most commonly expressed by the image of God the Father enthroned behind and above the Crucified Christ, the Timken panel, Meiss noted, was anomalous in replacing God the Father with the less-common symbol of the Trinity as a three-headed divinity (the triune God), usually employed independently of the Crucifixion. But even more unusual and disturbing, Meiss continued, was the approach to the representation itself:

> The image of three identical men, well known into the Middle Ages, is startling enough when carried into the more naturalistic and humanistic art of the fourteenth century. But our painter has not only eliminated their individuality of feature and dress; he has reduced and compromised their separate physical existence. Within a mandorla, two of the figures are seated close together; the third is between and behind them in an otherwise nonexistent space. Only two hands and two feet are visible, and the mantles of the two outer figures merge at the centre. The three men thus appear to be neither abnormal nor quite normal, and the painter has deliberately created an image of the greatest visual ambiguity.[50]

Placed within the context of post-plague imagery, the unusual form of the Trinity in the Timken panel was interpreted by Meiss in terms of a return to conservative dugento values. Viewed in this light, the choice of subject as well as the strict uniformity and regimentation of the figures provided Meiss with further evidence of a conscious intention in the art of this period to magnify the realm of the divine while reducing that of the human, in an effort to reassert the power of the Deity and the Church.

Meiss's view was taken up by Fehm in his own discussion of the Timken triptych, where the iconography of the central panel was related to the concept of transubstantiation (the conversion in the Mass of the host and wine into the Body and Blood of Christ), and the axial alignment of the Crucifixion and the Resurrection with the Trinity viewed as the visual expression of Christ's central role in the mystery of the Trinity.[51] By concentrating on the iconic value of the Trinity both Meiss and Fehm failed to notice, however, the existence of a narrative relationship between the scenes in the lateral shutters and the central panel, which would actually link the Timken triptych to more typical representations.

In the most recent discussion of the Timken triptych, Kanter correctly observes that the inclusion of the mourning figures of the Virgin and St. John with the kneeling St. Francis establishes the central scene not only as an iconic image of the Trinity but also as a devotional image of the Crucifixion, which completes the narrative sequence of Passion scenes in the right panel and central pinnacle.[52] According to Kanter, the presence of the devotional figure of St. Francis may provide an essential key for interpreting the iconography of the Timken triptych and the unusual conflation of narrative and iconic motifs, one more closely related to Franciscan spirituality and the theology of St. Bonaventure (1221–1274) than to a general post-plague concern with the expression of the supernatural. Following Kanter, I would suggest that it is worth speculating whether the overriding Christological emphasis that characterizes all three panels of the triptych could, in fact, be a precise reflection of the ideas expressed in St. Bonaventure's essay on the Trinity, "De mysterio Trinitatis," where the author reasserted the centrality of Christ's role in the Trinity through the mystery of Incarnation and, inspired by St. Francis's ideals, presented Christ's sacrifice for humanity as the ultimate expression of the love of God and the power of the Holy Spirit.[53]

Although Kanter has placed the execution of the Timken triptych before the 1357 Gabella cover, about 1355, the

increased sense of movement and expressive content of the scenes in the lateral panels suggest rather a later date, closer to the predella of the 1362 polyptych. The vivid quality of the two compartments with the Mocking of Christ and the Lamentation (figs. 16, 17) finds close analogies in the scenes of the Life of St. Thomas, where we find the same agitated figural types engaged in lively interaction. The excited movements of the fierce crowd of tormentors in the Mocking, caught in the various acts of insulting, slapping, and beating Christ with sticks, reflect the development of Luca's narrative style from the slightly more sober, stiffer qualities of the 1357 Gabella cover toward the distinctly personal, looser, and more dynamic idiom of the 1362 predella.

Luca's further progress from the Timken triptych is reflected in a series of four panels from the dismembered predella of a thus far unidentified altarpiece whose execution must only shortly predate the 1362 polyptych: a *Nativity* in a private collection; an *Adoration of the Magi* in the Thyssen-Bornemisza Collection, Madrid (fig. 18); a *Crucifixion* in the Fine Arts Museums of San Francisco (fig. 19); and a *Presentation in the Temple* (location unknown).[54] Virtually contemporary to these works, as noted by Fehm and Miklós Boskovits, is a small *Flagellation* in the Rijksmuseum, Amsterdam, that must originally have been included in the predella to another missing altarpiece (pl. 5).[55] It is in this image that we witness Luca's final transformation of Lorenzettian compositional formulae into an entirely original, direct narrative style, based on clearly articulated architectural settings and sophisticated spatial concerns. Derived from Pietro is the unusual motif of the broken ledge at the base of the composition; an inventive device that provides the viewer with an illusionistic access to the dramatic focus of the image, and for which we find a precedent in the already cited *Presentation* in Zagreb.

The fluid linear rhythms, darker palette, and expressive figural types that characterize these narrative images are

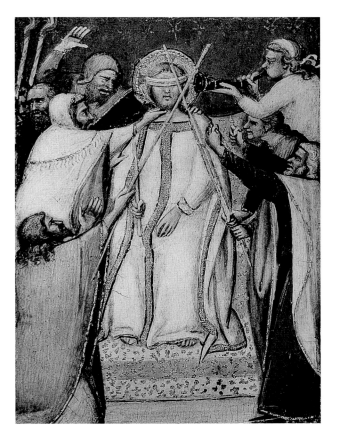

16. Luca di Tommè, detail of Timken Triptych, *Mocking of Christ*

17. Luca di Tommè, detail of Timken Triptych, *Lamentation*

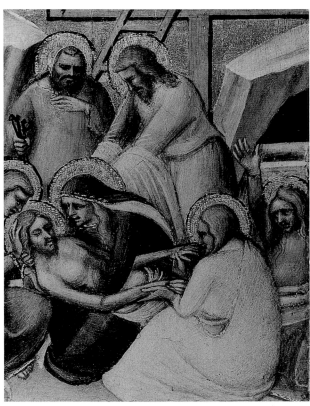

found also in other devotional panels from this period in Luca's career: a *Virgin and Child with Sts. John the Baptist and Catherine* from Polesden Lacey (fig. 20) and a processional banner with the Crucifixion in the Museo Civico in Montepulciano (fig. 21).[56] To these may be added a hitherto unrecognized work by Luca, a *Virgin and Child with Saints and Angels* in the Hermitage, St. Petersburg, which, although most recently attributed to the circle of Pietro Lorenzetti,[57] bears close analogies to the Montepulciano banner, as well as to the predella of the 1362 altarpiece.

Datable between the 1357 Gabella cover and the 1362 polyptych this fairly homogeneous and stylistically accomplished body of works confirms Luca's activity as an independent, fully mature artist before his collaboration with Niccolò di Ser Sozzo. The visual evidence gathered from the examination of these paintings suggests that Luca joined forces with Niccolò, not in the capacity of an assistant, but rather as an equal partner who was entrusted with the design as well as the execution of the entire predella of the 1362 polyptych. Beyond this, however, the extent of Luca's participation in the main panels is less clear. Fehm's proposal that Luca was also responsible for the design of the central panel[58] is contradicted by its close similarity to a virtually contemporary *Virgin and Child with Angels* by

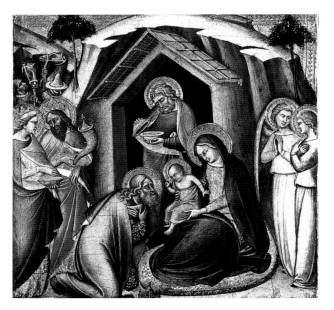

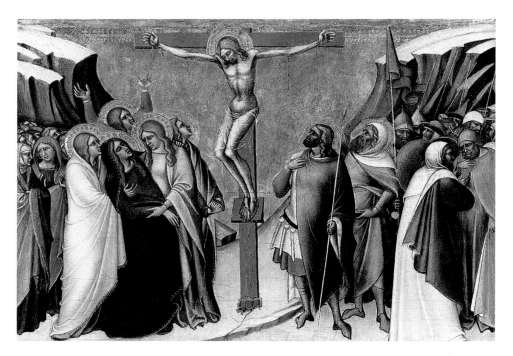

18. Luca di Tommè, *Adoration of the Magi.* Copyright © Fundación Colección Thyssen-Bornemisza, Madrid

19. Luca di Tommè, *Crucifixion.* Fine Arts Museums of San Francisco, Gift of the Samuel H. Kress Foundation, 61.44.3

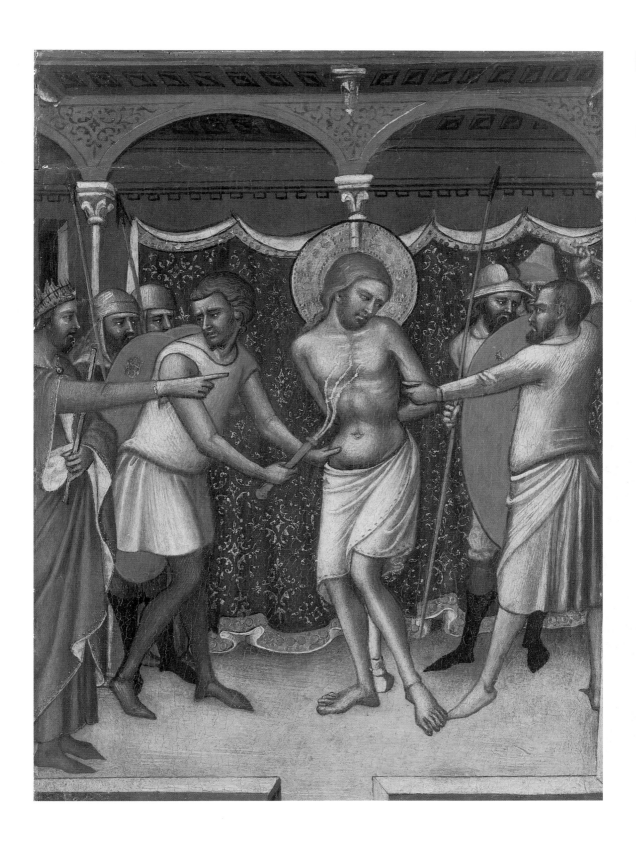

Pl. 5 LUCA DI TOMMÈ
Flagellation of Christ, ca. 1360–62
Tempera and gold on wood, 39 × 28.5 cm (15⅜ × 11¼ in.)
Rijksmuseum, Amsterdam, 1489E1

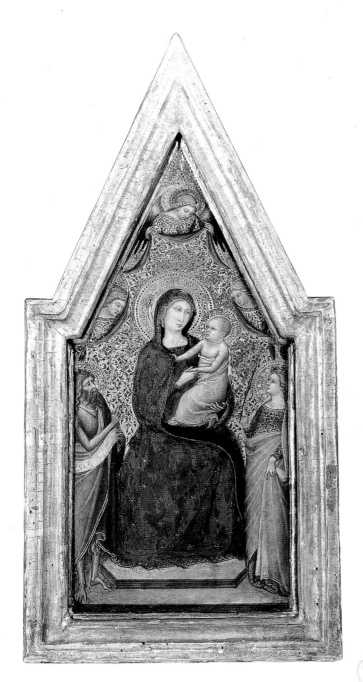

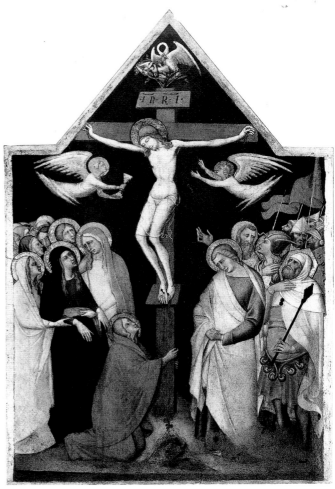

20. Luca di Tommè, *Virgin and Child with Sts. John the Baptist and Catherine of Alexandria.* The National Trust, Polesden Lacey, Surrey

21. Luca di Tommè, *Crucifixion.* Museo Civico, Montepulciano

Niccolò in the University of Arizona Museum of Art, Tucson (fig. 22), presently reduced from its original full-length size, where we find the same figural types as well, as spatial concerns. It is possible, on the other hand, that Luca did have a role in the execution, if not the design, of perhaps both of the saints in the left-hand panels of the Siena polyptych (fig. 23).[59] The figure of the Baptist, in particular, characterized by a darker palette and accentuated linear tension, as well as a more incisive definition of the human body—especially noticeable in the articulation

of the tendons and veins of the bare arm and feet—reflects the heightened expressivity of Luca's own pictorial vocabulary and finds a close counterpart, for example, in his St. John the Baptist from the St. Petersburg tabernacle. The same qualities, though perhaps less pronounced, appear in the depiction of St. Thomas. Compared to both these figures, the two saints in the right-hand panels (fig. 24), like the Madonna and Child, reflect the more generic, simplified articulation of forms and drapery typical of Niccolò's essentially decorative approach, perhaps

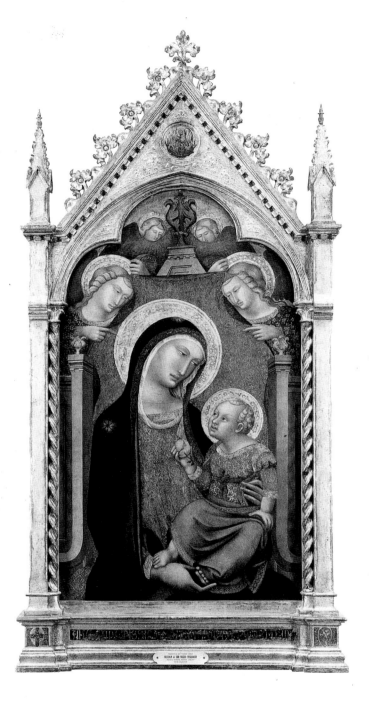

22 (above). Niccolò di Ser Sozzo, *Virgin and Child with Angels.*
University of Arizona Museum of Art, Tucson

23 (upper right). Luca di Tommè (?), *Sts. John the Baptist and
Thomas,* detail of Umiliati polyptych, fig. 1, Pinacoteca
Nazionale, Siena

24 (lower right). Niccolò di Ser Sozzo, *Sts. Benedict and Stephen,*
detail of Umiliati polyptych, fig. 1, Pinacoteca Nazionale,
Siena

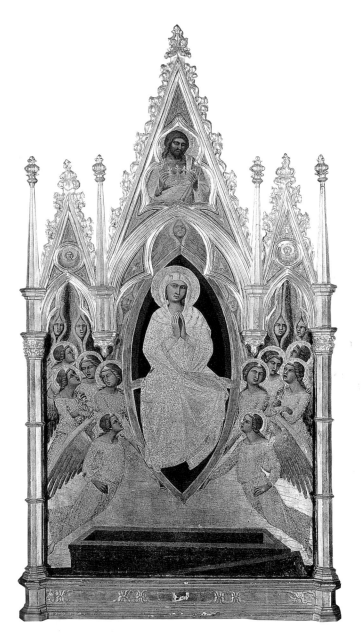

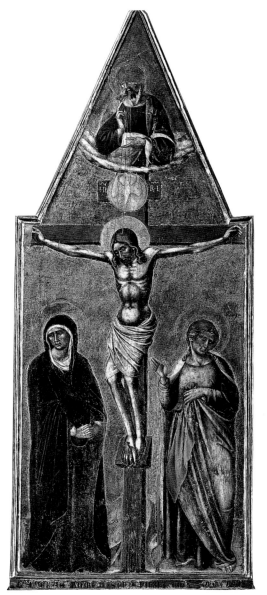

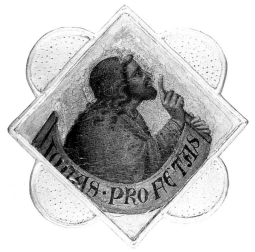

25 (above left). Luca di Tommè, *Assumption of the Virgin*. Yale University Art Gallery, New Haven

26 (left). Luca di Tommè, *The Prophet Jonah*. Museum Catharijneconvent, Utrecht, ABM s12

27 (above right). Luca di Tommè, *Crucifixion*. Museo Nazionale di San Matteo, Pisa

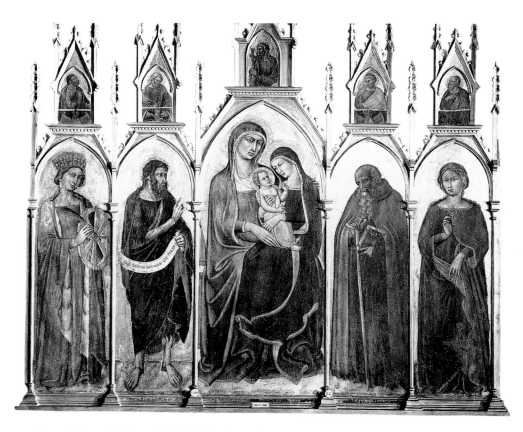

28. Luca di Tommè, *Virgin and Child with St. Anne, and Sts. Catherine of Alexandria, John the Baptist, Anthony Abbott, and Mustiola (?)*. Pinacoteca Nazionale, Siena. Photo courtesy of Alinari/Art Resource, New York

better suited to the demands of manuscript illumination than to painting on panel.

Luca's style on a large scale at this moment is reflected in a panel with the *Assumption of the Virgin* in the Yale University Art Gallery, New Haven (fig. 25). The size and structure of this work indicate that it was originally the central pinnacle of a major altarpiece, which may also have included, judging from the similarities in style and punch marks, a series of five panels with heads of prophets divided between the Rijksmuseum in Utrecht (fig. 26) and, formerly, a private collection in Florence. Both the Yale *Assumption* and the series of prophets were dated by Fehm to a period immediately following the 1362 polyptych, about 1362–65, although they were not associated by him in the same structure.[60] The strong similarity between the Virgin of the *Assumption* and the figure of St. Thomas in the 1362 polyptych, or between the heads of the angels supporting the mandorla, the prophets, and the figures in the

1362 predella suggests, however, a virtually contemporaneous date of execution.[61]

Firm reference points for Luca's style following the 1362 polyptych are provided instead by a large *Crucifixion* in the Museo Nazionale di San Matteo, Pisa, signed and dated 1366 (fig. 27) and a polyptych in the Pinacoteca Nazionale, Siena, signed and dated 1367 (fig. 28).[62] Characterized by a pronounced elongation of forms and heavy shading, along with a hardening of the facial features, these works mark the transition in Luca's style from the 1362 predella toward the increasingly expressionistic idiom of his late production as reflected in works such as the *Conversion of St. Paul* from the Seattle Art Museum, variously dated between 1374 and 1390 (pl. 6). Together with two other panels in the Pinacoteca Nazionale, Siena, showing the Sermon of St. Paul and St. Paul Led to His Martyrdom (figs. 29, 30), and a third panel in the Christian Museum, Esztergom, showing the Beheading of St. Paul,

Pl. 6 LUCA DI TOMMÈ
Conversion of St. Paul, ca. 1374
Tempera and gold on wood, 31.4 × 38.7 cm (12⅜ × 15¼ in.)
The Seattle Art Museum, Gift of the Samuel H. Kress
Foundation, 61.167

29. Luca di Tommè, *Sermon of St. Paul.* Pinacoteca Nazionale, Siena

30. Luca di Tommè, *St. Paul Led to His Martyrdom.* Pinacoteca Nazionale, Siena

the Seattle painting was originally included in what must have been the predella to a large altarpiece dedicated to St. Paul.[63] As recently suggested by Boskovits, the series may in fact constitute the predella to the lost St. Paul altarpiece commissioned by the Sienese Commune to celebrate the Sienese victory at the Battle of Valdichiana in 1363, for which Luca received payment in 1374.[64] Although the commission for this work may actually date, as noted above, to 1363, it is very possible that its execution, at a time of increased activity in Luca's career, could have been protracted over a number of years. Judging from the large

number of surviving altarpieces from this period, in fact, Luca was fully established at the head of what must have been one of the busiest workshops in Siena. In this regard it bears pointing out that while clearly indebted to compositional devices and figural types found in Luca's earlier production, the sketchier quality of the St. Paul scenes has often raised doubts as to Luca's actual participation in their execution, suggesting if not an altogether different hand, the possible intervention of assistants over his design.[65]

The issue of workshop intervention in Luca's later career is highlighted by the problems surrounding the

interpretation of a small body of works, clearly indebted to his pictorial vocabulary but falling outside the parameters of his securely attributed production. The paintings in question are a series of five scenes from the Life of the Magdalen divided between the Pinacoteca Nazionale, Siena (no. 212); the Pinacoteca Vaticana, Rome (no. 221); an unknown location; Hautcombe Abbey, Savoie; and the Museum of Fine Arts, Budapest (no. 28) (figs. 31–34); and two panels with St. Dominic and St. Lawrence, located respectively in the Rijksmuseum het Catharijneconvent, Utrecht, and in the Museum of Fine Arts, Budapest (figs. 35, 36). Recent opinion regarding these works is divided between those who, following Federico Zeri, attribute them to an early phase in Luca's career;[66] and others who, more appropriately, follow Meiss in considering the entire group as the product of a so-called Master of the Magdalen Legend, an anonymous Sienese follower of Luca.[67] The attenuated figures, vibrant palette, incisive outlines, and heavy shading that characterize these paintings do indeed reveal closer analogies with Luca's late production, in particular as exemplified by the St. Paul predella, than with any of the works thus far associated with an earlier phase in Luca's career. Possibly also included in the production of

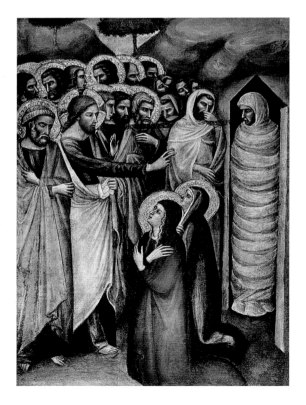

31. Master of the Magdalen Legend, *Mary Magdalen Anointing the Feet of Christ.* Pinacoteca Nazionale, Siena. Photo courtesy of the Institute of Fine Arts, New York University, Richard Offner Collection

32. Master of the Magdalen Legend, *Raising of Lazarus.* Pinacoteca Vaticana, Rome

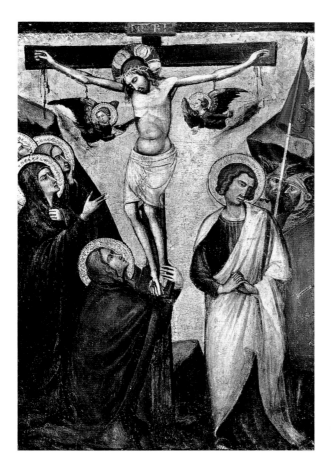

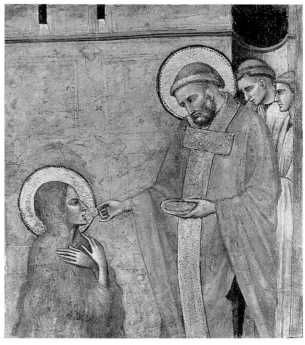

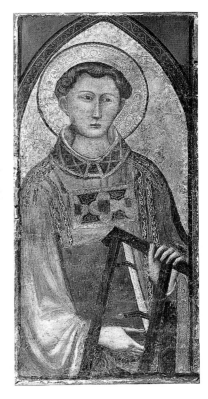

33. Master of the Magdalen Legend, *Crucifixion.*
Location unknown. Photo courtesy of the
Institute of Fine Arts, New York University,
Richard Offner Collection

34. Master of the Magdalen Legend, *Communion of
Mary Magdalen.* Museum of Fine Arts, Budapest

35. Master of the Magdalen Legend, *St. Dominic.*
Museum Catharijneconvent, Utrecht, ABM s20

36. Master of the Magdalen Legend, *St. Lawrence.*
Museum of Fine Arts, Budapest

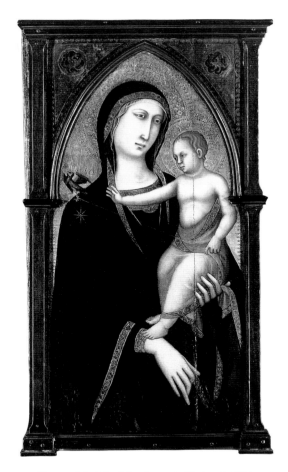

37. Master of the Magdalen Legend, *Virgin and Child.*
Sotheby's, New York, Jan. 11, 1996, lot 47

the Magdalen Master, in fact, is a *Virgin and Child* recently on the art market (Sotheby's, New York, Jan. 11, 1996, lot 47; fig. 37), which though published by Gaudenz Freuler as Luca's earliest surviving work,[68] represents rather a close derivation of the master's style as reflected in the central panel of the Perugia polyptych (fig. 38), which is generally dated to the same period as the St. Paul predella.[69] The same hand may also be identified in another panel closely related to the *Virgin and Child* and perhaps part of the same original complex, a St. Peter from the church of San Pietro Ovile in Siena (Pinacoteca Nazionale, Siena) attributed by Fehm to Luca's workshop.[70]

Luca's earliest production may be represented instead by another small group of works that, although firmly attributed to the artist, reflects significant points of contact, both technical and stylistic, with the production of Niccolò di Ser Sozzo in the early 1350s. These are a small panel of the Virgin and Child with Sts. Louis of Toulouse and Michael and two angels in the Los Angeles County Museum of Art (pl. 7) and a series of seven panels from a dismembered altarpiece, showing Sts. John Gualbert, Michael, and Bernardo degli Uberti (private collection; figs. 39–41); St. John the Baptist (J. Paul Getty Museum, Malibu; fig. 42); Sts. Paul and Peter (ex-art market, Milan); two unidentified apostles (Fondazione Roberto Longhi,

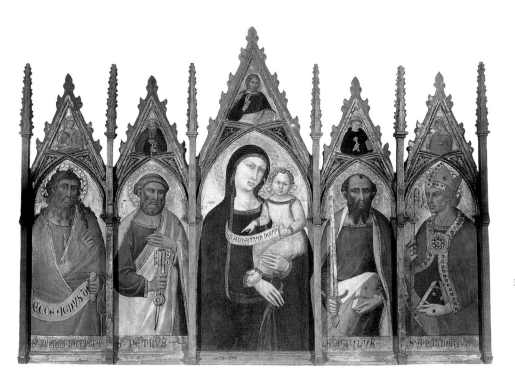

38. Luca di Tommè, *Virgin and Child with Sts. John the Baptist, Peter, Paul and Apollinaris.* Galleria Nazionale dell'Umbria, Perugia. Photo courtesy of Alinari/Art Resource, New York

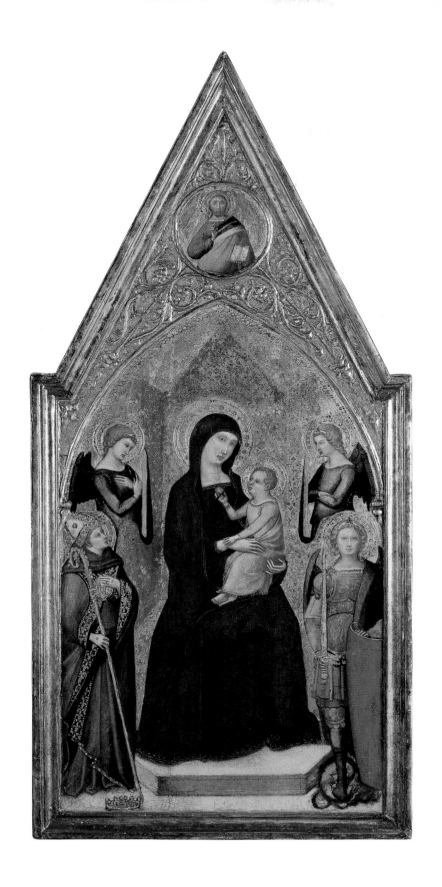

Pl. 7 LUCA DI TOMMÈ

Virgin and Child with Sts. Louis of Toulouse and Michael, and Angels, ca. 1350–55

Tempera and gold on wood, 55.2 × 26.7 cm (21¾ × 10½ in.)

Los Angeles County Museum of Art, anonymous donor, 57.68

39 (above left). Luca di Tommè, *St. John Gualbert.* Private collection

40 (above center). Luca di Tommè, *St. Michael.* Private collection

41 (above right). Luca di Tommè, *St. Bernardo degli Uberti.* Private collection

42 (left). Luca di Tommè, *St. John the Baptist.* J. Paul Getty Museum, Los Angeles

Florence); and the Blessing Redeemer (North Carolina Museum of Art, Raleigh; pl. 8).

Once attributed to Ambrogio Lorenzetti, the Los Angeles panel (pl. 7) is now generally considered among Luca's earliest surviving works.[71] Variously dated between 1355 and 1361, it has been compared to paintings such as the Fogg *Crucifix* and the Timken triptych, with which it undoubtedly shares a clear dependence on Lorenzettian compositional models, as well as a refinement in execution. At the same time, however, the lighter palette and softer modeling of this image stand in marked contrast to the sharper definition of forms and increased expressiveness of Luca's first mature efforts, beginning with the 1357 Gabella cover and leading to the Fogg *Crucifix* and Timken triptych. In this respect, the Los Angeles panel suggests, rather, an earlier phase in the artist's career, predating these works.

The paintings most closely related to the Los Angeles panel are the seven fragments from a dismembered altarpiece first attributed to Luca di Tommè by Roberto Longhi.[72] Based on the presence of St. Michael and two Vallombrosan saints, John Gualbert and Bernardo degli Uberti, Zeri has associated this series with an altarpiece for the Vallombrosan church of San Michele in Siena, no longer extant, dating its execution to a period shortly before the 1362 polyptych.[73] As in the Los Angeles panel, however, the clear palette and broader definition of forms in the San Michele altarpiece find no equivalent in Luca's mature production following the 1357 Gabella cover. They do, on the other hand, find a close point of reference in the production of Niccolò di Ser Sozzo about the time of the Uffizi *Virgin and Child* (fig. 7), datable to the early 1350s and characterized by the same blond tonalities and generalized figural style of the artist's earlier miniature production. In this regard the Uffizi panel and the San Michele altarpiece represent the closest point of contact between Niccolò's and Luca's idiom at any given moment of their respective careers.

Beyond such stylistic affinities, a comparison of punch marks in the San Michele altarpiece with those found in Niccolò's work provides revealing evidence of an actual association between the two artists at this date. The border decoration in the cope of St. Bernardo degli Uberti (fig. 41), in fact, includes the same punch mark that appears in the Uffizi *Virgin and Child,* as well as in several

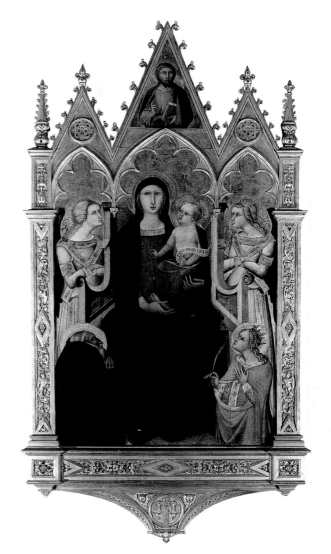

43. Niccolò di Ser Sozzo, *Virgin and Child with Sts. Anthony Abbott, Catherine of Alexandria, Paul, and Peter.* Museo della Società Esecutori di Pie Disposizioni, Siena

other works associated with this period in Niccolò's activity, such as the polyptych in the Museo della Società Esecutori di Pie Disposizioni, Siena (fig. 43), and the *Crucifix* by his anonymous assistant in the church of Santo Spirito, Siena (fig. 11). Derived from the workshop of Ambrogio Lorenzetti, this punch was previously identified by Skaug in Niccolò's production, but not in that of any other contemporary painter.[74] Its appearance in Luca's altarpiece would seem to provide, therefore, new technical evidence of the existence of a concrete relationship between the two artists, preceding their collaboration on the 1362 altarpiece. That this was not a master-pupil relationship has already

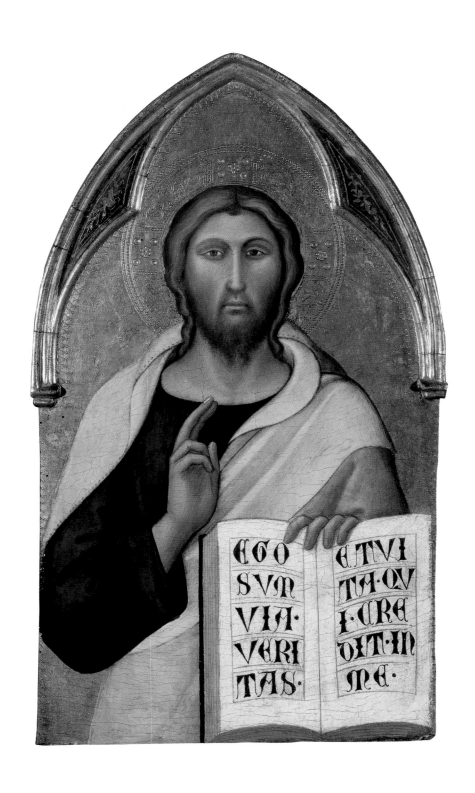

Pl. 8 LUCA DI TOMMÈ
Christ Blessing, ca. 1350–55
Tempera and gold on wood, 58.1 × 33.7 cm (22⅞ × 13¼ in.)
North Carolina Museum of Art, Raleigh, Gift of the
Samuel H. Kress Foundation, GL.60.17.5

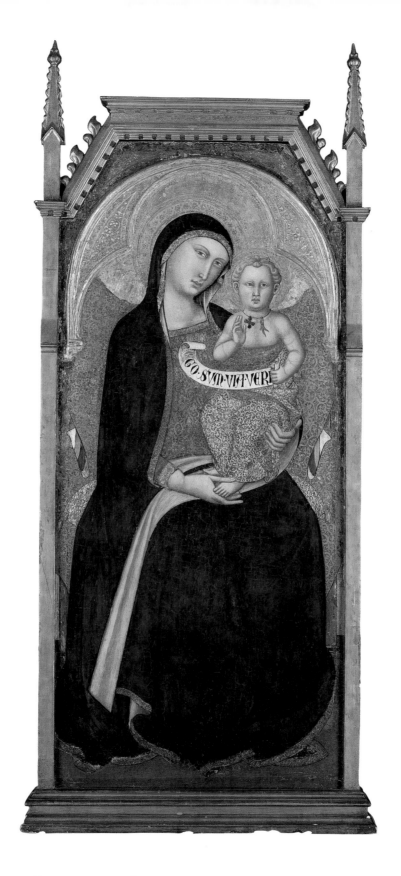

Pl. 9 LUCA DI TOMMÈ
Madonna and Child, ca. 1362
Tempera and gold on wood, 134.3 × 58.7 cm (52⅞ × 23⅛ in.)
The Metropolitan Museum of Art, New York, Gift of George
Blumenthal, 1941 (41.100.34)

been suggested, and it is confirmed by the subtle modeling of the figures in both the Los Angeles panel and San Michele altarpiece, which clearly distinguishes Luca's idiom from Niccolò's essentially abstract approach. It is possible, however, that after emerging from Pietro's shop, about 1348, Luca joined forces with Niccolò, an older and more established master, in a formal business relationship, possibly along the lines of the kind of *compagnia* outlined by Skaug and other scholars, temporarily pooling their technical resources in a single workshop.[75] Whether or not such an arrangement was motivated by a general, increased demand for works of art following the plague, as suggested by Cohn, or by the particular requirements of Niccolò's growing involvement in the production of panel paintings as opposed to manuscript illumination, remains open to debate. Visual and technical evidence does suggest, however, that by 1357 at the latest, Luca had broken away from the partnership to set up his own independent workshop.

In light of these observations, Fehm's explanation for the collaboration between the two artists on the 1362 polyptych does not seem adequate. Based on the assumption that Niccolò was not an independent artist until 1363, when his name appears for the first time among the members of the painters' guild, Fehm had proposed that he temporarily joined Luca's workshop before establishing his own practice.[76] Such a theory fails to take into account, however, the fact that the 1363 list is actually the earliest surviving document of its kind—the putative 1356 list having been compiled, as already noted, sometime between 1378 and 1386 —and therefore offers no documentary basis for ascertaining the start of Niccolò's independent career.[77] Niccolò's responsibility for the design of the main panels of the 1362 polyptych, moreover, confirms his seniority in this commission. Beyond this, it has already been noted that the mature style evidenced by Niccolò's miniature production, most notably the Caleffo *Assumption,* and its dating after 1342, imply that Niccolò had established an independent practice well before the 1362 altarpiece, perhaps about the time of his first mention as a painter in the 1348 document and coinciding with the death of the Lorenzetti brothers, from whom he inherited a fair number of his punch tools.

Although we may never know the exact circumstances surrounding the production of the 1362 altarpiece, there is reason to believe that the commission for this work was initially awarded to Niccolò, and that Luca was called in by

him to assist in the execution, based on their previous association at an earlier date. It remains to be determined, however, whether their collaboration was limited to this single episode. Although the greater part of Luca's production prior to and after the 1362 polyptych follows a uniform pattern of development characterized by the evolution of the artist's personal idiom from the 1357 Gabella cover, a notable exception is constituted by a monumental *Madonna and Child,* originally the central panel of a large polyptych, from the Metropolitan Museum of Art (pl. 9).[78] Generally related in both style and composition to the central compartment of the 1362 polyptych, this work has been dated by Fehm to a period immediately following the execution of the latter, between 1362 and 1365, and presented as the clearest indication of the impact of Luca's collaboration with Niccolò on his subsequent production.[79] It could equally be argued, on the other hand, that the pronounced affinity in physiognomic types and palette between this image and the lefthand panels of the 1362 polyptych (fig. 23) or the closely related Yale *Assumption* (fig. 25) is not only indicative of a virtually contemporary date of execution but may in fact reflect another instance of collaboration between the two independently established artists, in the production of a largescale altarpiece.[80]

NICCOLÒ DI BUONACCORSO

The issue of workshop collaboration in the second half of the fourteenth century is nowhere more a factor than in the evaluation of Luca di Tommè's slightly younger contemporary, Niccolò di Buonaccorso. Generally recognized as one of the rarest and most engaging Sienese artists of the last half of the fourteenth century, Niccolò di Buonaccorso is known primarily for his production of smallscale altarpieces for private devotion, characterized by precious decorative effects and sophisticated spatial concerns. Often surviving in three or four variants of the same composition, these works appear to have enjoyed an enormous popularity in Siena and reflect the artist's role at the head of an active workshop. The formulaic repetition of his models in the production of minor artists, however, together with the scarcity of biographical information or firmly documented works have frustrated attempts to establish the exact parameters of Niccolò's career and to assess his proper role in the history of Sienese painting.

Presumably a son of the Sienese painter Buonaccorso

di Pace, Niccolò di Buonaccorso is first documented in 1372, when he is mentioned as one of the Priori (Priors) for his residential district, the Terzo di Camollia.[81] In 1375 he was elected, together with the painter Bartolo di Fredi, as one of the representatives from the Terzo di Camollia to supervise the creation of the new election ballot.[82] In 1377 he appears once more as one of the Priors for the Terzo di Camollia, and in 1381 as a Gonfaloniere for the same district. The only documentary reference to a work of art is a 1383 payment record to Niccolò from the Opera del Duomo, for a panel of St. Daniel that is yet to be identified. Sometime between 1378 and 1386 Niccolò must have registered in the painters' guild, for his name appears after that of Andrea Vanni in the list of artists appended during those years to the 1356 statutes.[83] In 1384 he is mentioned again in the records of the Sienese General Council. Four years later, on May 17, 1388, his name appears among those buried in the Sienese convent of San Domenico.[84]

The artistic personality of Niccolò di Buonaccorso was first identified in 1854 by Gaetano Milanesi, who recorded having seen in the church of Santa Margherita at Costalpino, outside Siena, two fragments of an altarpiece showing, respectively, a St. Lawrence, repainted to depict a St. Margaret, and a Virgin and Child Enthroned below which was the signature: "NICHOLAUS: BONACHURSI. ME. PINXIT. A. DNI. 1387" (Niccolò di Buonaccorso painted me in the year of the Lord 1387).[85] By the time Francesco Brogi inventoried the contents of Santa Margherita in 1862, however, the signed panel with the Madonna and Child had disappeared, thus leaving the repainted, largely damaged St. Lawrence, in turn removed to the nearby church of Sant'Andrea a Montecchio, as the only testimony of Niccolò's production.[86]

The first step toward establishing a corpus of works for the artist was made in 1881, when the National Gallery in London purchased a small panel with the Marriage of the Virgin, signed "NICHOLAUS: BONACHURSI: DE SENIS: ME P[I]NX[I]T" (fig. 44). Subsequently identified as the central compartment of a portable triptych that also included a *Presentation of the Virgin* in the Uffizi, Florence (fig. 45), and a *Coronation of the Virgin* in the Robert Lehman Collection in the Metropolitan Museum of Art, New York (pl. 10),[87] this work provided the basis for the attribution to Niccolò of a number of other stylistically related, small panels for private devotion, uniformly

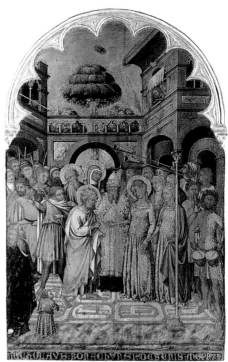

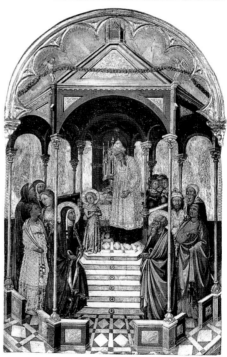

44. Niccolò di Buonaccorso, *Marriage of the Virgin.* Reproduced by courtesy of the Trustees of The National Gallery, London

45. Niccolò di Buonaccorso, *Presentation of the Virgin in the Temple.* Galleria degli Uffizi, Florence. Photo courtesy of the Institute of Fine Arts, New York University, Richard Offner Collection

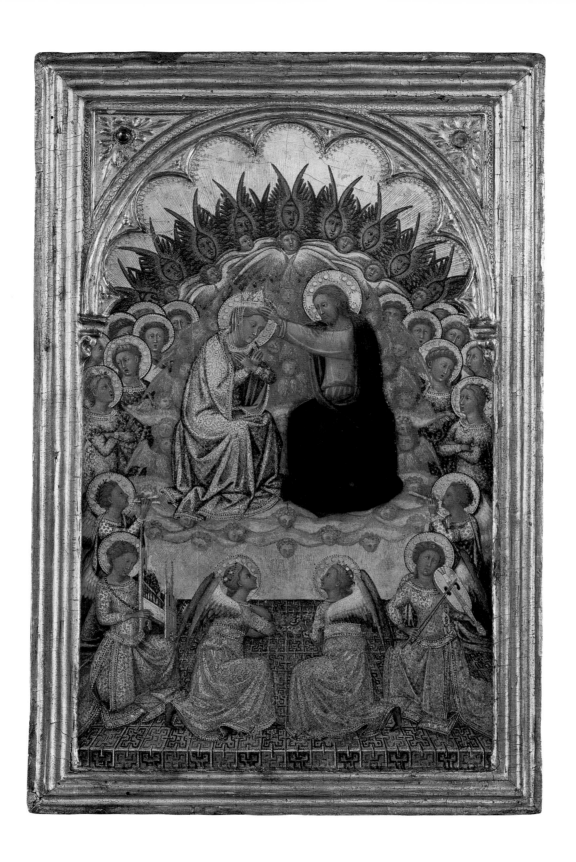

Pl. 10 NICCOLÒ DI BUONACCORSO
Coronation of the Virgin, ca. 1380
Tempera and gold on wood, 50.7 × 32.8 cm (20 × 12⅞ in.)
The Metropolitan Museum of Art, New York, Robert Lehman Collection.
(1975.1.21)

characterized by elaborate decorative surface effects and an almost miniature-like technique of execution.[88] The result was an image of the painter as a technically accomplished but minor master who worked exclusively on a reduced scale, producing charming but essentially repetitive images for a wide popular market.

It was only in relatively recent times that the fuller scope of the artist's ambitions and capabilities was revealed to scholars with the recovery of the lost central fragment from the signed and dated 1387 altarpiece in Santa Margherita at Costalpino, identified by Boskovits with a large *Madonna and Child* in the Kisters collection, Kreuzlingen (pl. 11).[89] The reinsertion of this panel within Niccolò's oeuvre has allowed for the attribution to him of several other works on a monumental scale, confirming the artist's actual, if limited, involvement in the execution of ambitious altarpiece commissions in addition to his more prolific though modest production for private devotion.

Aside from the 1387 altarpiece, the only firm point for Niccolò's career is the nearly contemporary 1385 Biccherna cover with the allegory of Government Restored Restraining the Citizens in the Archivio di Stato, Siena, first attributed to the artist by John Pope-Hennessy and Laurence Kanter (fig. 46).[90] The completion of both these works only a few years before Niccolò's death, however, and the relative homogeneity of his remaining production have frustrated attempts to trace a clear picture of the artist's development. Complicating the issue is the fact that most scholars still place the beginning of the artist's career in 1356, mistakenly assuming the list of painters appended to the statutes of that year to be contemporaneous in date.[91] The result is the impression of an artist caught in the repetition of the same tired formulae over the course of a thirty-year career. Following Cesare Brandi, however, it has reasonably been suggested that Niccolò's birth date be placed in or about 1348, the year when the artist's putative father, Buonaccorso di Pace, was married, leading to the alternative view of his development within the parameters of a brief career that began only in the 1370s, coinciding with the first mention of his name in public office, and cut short by an early death in 1388.[92]

If Niccolò was indeed the son of the painter Buonaccorso di Pace, there is little evidence to support speculation that he might actually have trained in his father's studio. Still an obscure personality in the history of Sienese paint-

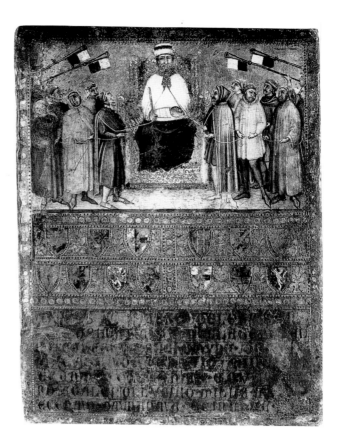

46. Niccolò di Buonaccorso, Biccherna cover with *Allegory of "Government Restored Restraining the Citizens."* Archivio di Stato, Siena. Photo courtesy of the Institute of Fine Arts, New York University, Richard Offner Collection

ing, the senior Buonaccorso is known only through archival documents, none of which pertain to a work of art or commission.[93] The only exception is constituted by a record dated 1358 in which the artist, referred to for the first time as "dipentore e maestro architectore," is asked to supervise the construction of the Sienese fortifications at Monticiano. Aside from the already mentioned notice of his marriage in 1348, however, the few remaining documents refer to Buonaccorso's various elections to public office. The last record of his activity is the inclusion of his name in the 1363 list of masters in the painters' guild. That same year his death is registered in the Necrologio of San Domenico together with those of two other sons, possibly all of them having fallen victim to the same outbreak of the plague that took the life of Niccolò di Ser Sozzo.[94]

Although Buonaccorso's activity as an architect might offer a specific clue for Niccolò's particular flair in the

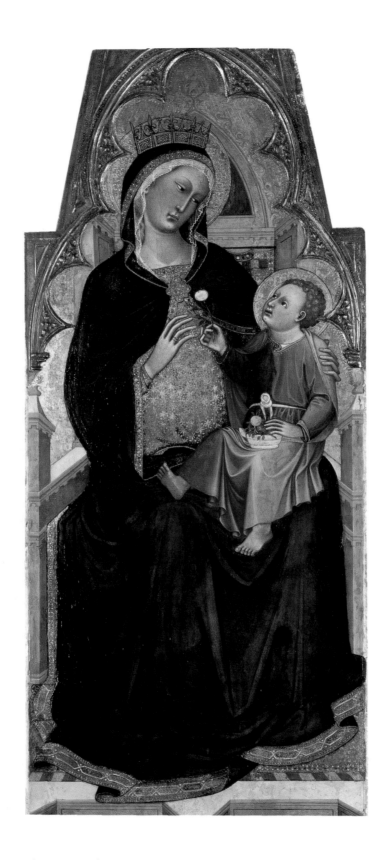

Pl. 11 NICCOLÒ DI BUONACCORSO
Madonna and Child, 1387
Tempera and gold on wood, 152.5 × 58.5 cm (60 × 23 in.)
Heinz Kisters Collection, Kreuzlingen

depiction of convincing domestic interiors and sophisticated architectural settings, most scholars concur in seeking the roots of his idiom in the advanced spatial experiments and decorative concerns of Ambrogio Lorenzetti. More specifically, it has been suggested that the artist, who was too young to have actually trained under the Lorenzetti, may have received his initial formation in the 1360s in the workshop of one of the most successful assimilators of Ambrogio's spatial and decorative vocabulary, Jacopo di Mino del Pellicciaio.[95] Additional reference points for Niccolò's early development, however, may also be found in the production of painters trained in the circle of Simone Martini, such as Jacopo di Mino's lesser-known contemporary and possible collaborator, Naddo Ceccarelli, whose figural style, characterized by more loosely articulated forms and more fluid linear rhythms than Jacopo di Mino's, finds a particularly strong echo in Niccolò's small-scale works.[96] Niccolò's production in the final years of his brief career is strongly influenced, on the other hand, by the example of his slightly older contemporary Bartolo di Fredi, whose paintings of the 1380s are reflected in Niccolò's last monumental works.

As noted above, the only firm reference point for an evaluation of Niccolò's style prior to the recovery of the Santa Margherita at Costalpino altarpiece was provided by the signed triptych with scenes from the Life of the Virgin, now divided between the National Gallery, London, the Uffizi, Florence, and the Robert Lehman Collection in the Metropolitan Museum of Art, New York (figs. 44, 45, pl. 10). Characterized by a miniaturist quality of execution and elaborate decorative surface effects, this work takes its place within the tradition of luxury portable altarpieces produced in Siena throughout the first half of the fourteenth century. The presence of a metal stud and what appears to be a hinge on the left and right respectively of the Uffizi *Presentation* and the complex decoration on the back of all three panels—silvered, punched, and painted with a pattern of diamond-shaped lozenges in blue and red (fig. 47)—confirming that they were intended to be seen on both sides, has led to speculation that the altarpiece be placed in the same category as Simone Martini's famous Orsini polyptych, comprising a series of four panels with scenes from the Life of Christ that folded on each other accordion-style.[97] On the other hand, the lack of evidence that hinges were ever present on the sides of either the National Gallery or Lehman panels and the appearance of gilding and punchwork around all four edges of the latter and along the unplaned right edge of the former might point to another type of movable altarpiece composed of independent elements requiring some sort of supporting armature, perhaps on the model of Simone Martini's 1326 polyptych for the Cappella dei Signori.[98] Regardless of its arrangement, however, it is likely that the complex did originally include, as first observed by Luisa Marcucci, one or more additional scenes from the Life of the Virgin, such as her birth, the Annuciation, or the Assumption.[99]

Their sophisticated architectural settings and lively anecdotal quality locate Niccolò's three panels within the best Sienese narrative tradition as represented by Simone Martini and the Lorenzetti brothers, whose famous lost frescoes with scenes from the Life of the Virgin on the facade of the Hospital of Santa Maria della Scala, in Siena, may in fact

47. Niccolò di Buonaccorso, reverse of pl. 10

48. Sano di Pietro, *Presentation of the Virgin in the Temple.*
Pinacoteca Vaticana, Rome

have provided a direct model for the artist. Significantly, the closest parallel for the Uffizi *Presentation of the Virgin in the Temple,* with its lucidly articulated interior defined in depth by the receding floor-tile pattern and by the series of steps leading up to the altar, is found in the corresponding scene executed almost a century later by Sano di Pietro in the Cappella de Signori predella, a work specifically commissioned in imitation of the hospital frescoes (fig. 48).[100] If the Uffizi *Presentation,* like Sano's, is indebted to the composition painted for the hospital by Ambrogio Lorenzetti, the National Gallery *Marriage of the Virgin,* reflects, on the other hand, Niccolò's own innovative adaptation of the models provided by Simone Martini in his two frescoes of the Marriage and of the Virgin Returning to the House of Her Parents. Once again, a comparison with Sano di Pietro's supposedly faithful copies of these scenes (figs. 49, 50) suggests that Niccolò skillfully conflated elements derived from each, by depicting the Marriage, originally set in a vaulted interior, in an open courtyard framed by structures on both sides. The result is a greater impression of space, defined in the background by the view through a vaulted archway into a garden or street from which rise delicately feathered trees, and an increased narrative vivac-

ity, provided by the addition of such anecdotal details as the curious onlookers leaning from the window of the building on the right.

The ambitious spatial settings that characterize the compositions of the Uffizi and National Gallery panels are complemented by a precious, miniaturist quality of execution that is highlighted by the extensive use of sgraffito decoration (the technique of incising patterns through a painted surface to reveal the underlying gold ground) for the brocade robes of the figures and by the modeling of the draperies with brilliant effects of *changeant couleur.* These elements are especially evident in the sumptuous panel with the Coronation of the Virgin in the Lehman collection (pl. 10), dominated by the luminous effect of the gilded ground applied to the entire surface of the picture and by the glowing palette of bright reds, oranges, and yellows used both as areas of solid tempera and as translucent glazes. In this respect, the Lehman painting emphasizes Niccolò's debt to the late Gothic, courtly idiom of Simone Martini as much as to the advanced spatial experiments of the Lorenzetti.

As pointed out by Meiss, Niccolò's representation of the Coronation represents the earliest example in Siena

49. Sano di Pietro, *Marriage of the Virgin*. Pincoteca Vaticana,
 Rome. Photo courtesy of Alinari/Art Resource, New York

50. Sano di Pietro, *The Virgin Returning to the House of Her Parents*.
 Staatliches Lindenau-Museum, Altenburg. Photo courtesy of
 the Institute of Fine Arts, New York University, Richard
 Offner Collection

of a novel type of composition first developed in Florence about 1360, showing Christ and the Virgin suspended above the ground rather than seated on a throne set on a floor or platform and surrounded by saints and angels.[101] Although the appearance of this type of iconography, derived from thirteenth-century models and intended to emphasize the supernatural quality of the event, is interpreted by Meiss as an example of the conscious return to conservative aesthetic values following the Black Death, the feeling of depth that is conveyed in Niccolò's panel by the sharply receding floor pattern and the resulting creation of a convincing spatial setting separate his image from any iconic representation of the previous century. Viewed in this light, the Lehman *Coronation* reflects, rather, the same entirely personal and innovative interpretation of older prototypes that characterized the artist's Uffizi and National Gallery panels.

On the basis of its accomplished stylistic and formal qualities, the Uffizi-National Gallery-Lehman complex has been viewed as a product of Niccolò's mature career and plausibly dated about 1380,[102] slightly preceding the harder-edged idiom of the 1385 Biccherna cover and the 1387 Costalpino altarpiece, but later than the more loosely articulated forms seen in works possibly executed in the previous decade of his activity, such as the triptych from the Timken Museum of Art (pl. 12).

Most recently dated about 1370 or 1375 by Kanter, the Timken triptych represents one of the earliest examples of the kind of small portable altarpiece of the Virgin and Child with saints produced in various versions by Niccolò and his workshop.[103] The present version, showing the Virgin seated on the ground surrounded by domestic furnishings and knitting implements, was repeated by Niccolò in a later panel, executed about the same time of the Costalpino altarpiece, now in the Musée du Louvre, Paris.[104] The inclusion of sewing implements as attributes of the Virgin in both these works, as first pointed out by Meiss, represents a variation of the popular theme of the Virgin of Humility that seems to have originated in the circle of the Lorenzetti.[105] It has reasonably been proposed that the development of this motif, whose significance is connected with the notion of Mary's virtues of chastity and poverty, might be specifically related to the ideals of poverty and chastity promoted by Franciscan reform spirituality, alluded to by the presence of a diminutive St. Francis kneeling at

the foot of the cross in the central pinnacle of the Timken triptych.[106]

Closely related in style to the Timken triptych is the earliest example of the kind of small-scale Maestà compositions produced in Niccolò's shop; a *Virgin and Child Enthroned Surrounded by Sts. Mary Magdalen, John the Evangelist, Catherine of Alexandria, and Thomas,* in the Pinacoteca Nazionale, Siena (fig. 51). Although the attribution of this panel to Niccolò has sometimes been questioned,[107] the softly drawn contours and elongated figural types find a close point of reference in the Timken triptych, as well as in other works unanimously given to the artist and datable to the same period, such as the pair of grisaille tabernacle shutters in the Alte Pinakothek, Munich (figs. 52, 53);[108] a panel with St. Lawrence, in the Glasgow Art Gallery (fig. 54);[109] and, last but not least, a larger version of the same composition, with only two saints but showing the

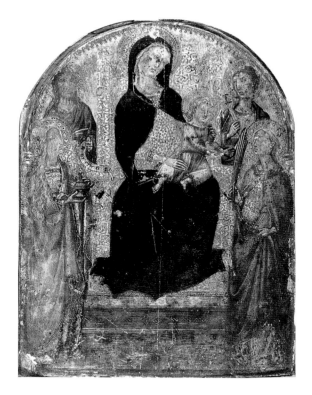

51. Niccolò di Buonaccorso, *Virgin and Child Enthroned Surrounded by Sts. Mary Magdalen, John the Evangelist, Catherine of Alexandria, and Thomas.* Pinacoteca Nazionale, Siena. Photo courtesy of the Institute of Fine Arts, New York University, Richard Offner Collection

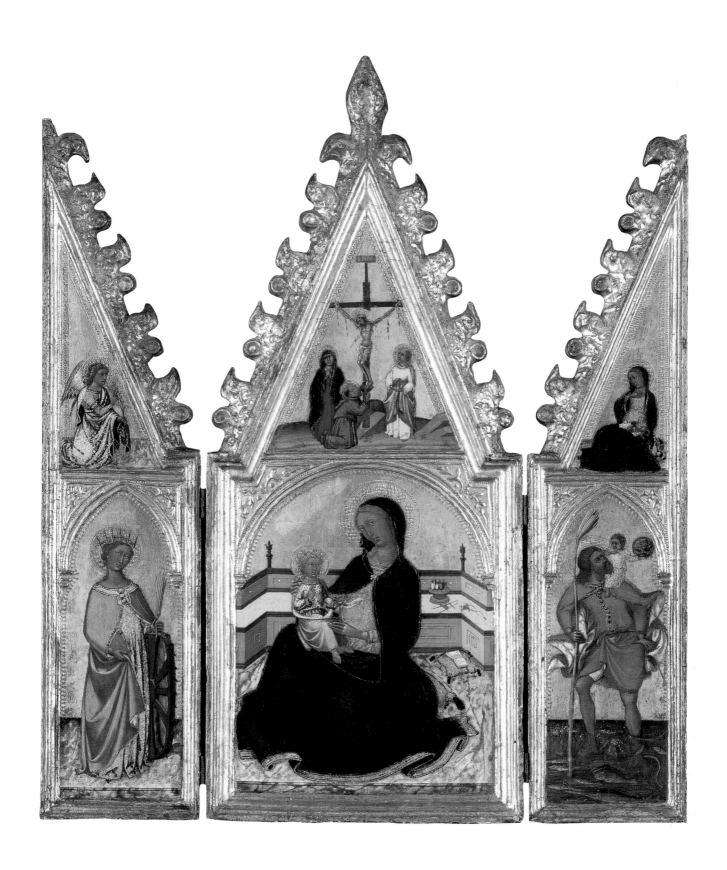

Pl. 12 NICCOLÒ DI BUONACCORSO
Triptych: *The Virgin of Humility, with Sts. Catherine of Alexandria and*
Christopher, the Annunciation, and the Crucifixion, ca. 1370–75
Tempera and gold on wood, 65.4 × 53.4 cm (25¾ × 21 in.)
Timken Museum of Art, San Diego, 1967.2

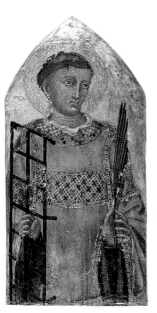

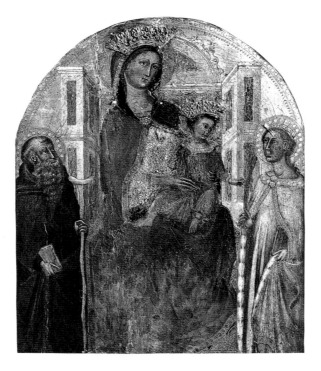

52, 53. Niccolò di Buonaccorso, details of tabernacle shutters: *Annunciatory Angel and Standing Saints* (above). Alte Pinakothek, Munich. Photo courtesy of the Institute of Fine Arts, New York University, Richard Offner Collection

54. Niccolò di Buonaccorso, *St. Lawrence* (far left). Glasgow Museums: Art Gallery and Museum, Kelvingrove

55. Niccolò di Buonaccorso, *Virgin and Child with Sts. Anthony Abbott and Catherine of Alexandria* (left). Location unknown. Photo courtesy of the Institute of Fine Arts, New York University, Richard Offner Collection

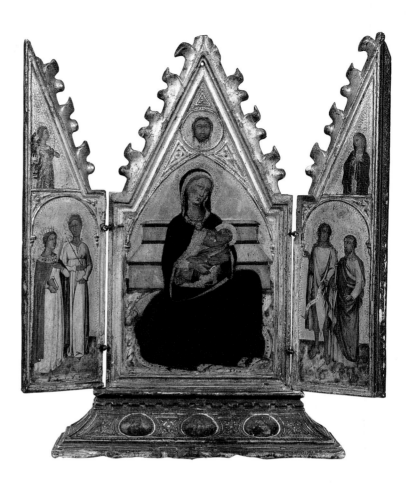

56. Niccolò di Buonoccorso. *Portable Triptych with Madonna of Humility.* Indiana University Art Museum, Bloomington, © 1997: Indiana University Art Museum

Christ Child in the same pose, turning toward St. Catherine, formerly located in a street tabernacle in Siena (fig. 55).[110] In light of the widespread popular devotion that typically surrounded such street tabernacles, placed on view to the general public, it is tempting to speculate whether this last composition did in fact provide the model for the painting in the Pinacoteca Nazionale, perhaps one of several small-scale versions produced in Niccolò's shop for private worship.

The beginning of the second decade of Niccolò's activity, about the time of the Uffizi-National Gallery-Lehman complex, is marked by the increased production of the kind of small-scale devotional altarpiece represented by the Timken triptych and by the Pinacoteca Nazionale panel. Datable to this period is the portable triptych in the Indiana University Art Museum, Bloomington (fig. 56), which represents a third, reduced version of the Timken and Louvre compositions of the Madonna of Humility, showing the Virgin suckling her child as in the latter, but without any of her sewing attributes.[111] It should be noted that the reduced width of the bench structure in this paint-

ing reflects not so much a simplification of the Timken version as the artist's particular design skills in adjusting his composition according to the specific requirement of the vertical picture surface, as opposed to the wider dimensions of the Timken panel. Doubtless contemporary to the Bloomington altarpiece is the central fragment of a triptych with the Virgin and Child surrounded by six standing saints, in the Pinacoteca Nazionale, Siena (fig. 57),[112] in which the virtually identical pose and definition of the suckling child and of the Virgin's upper body suggest the use of a pattern book in adapting details of one composition to the other.[113]

Although clearly focused on the production of small-scale devotional panels, the second decade of Niccolò's activity was also marked, as revealed by the recovery of the signed and dated 1387 Santa Margherita at Costalpino altarpiece (pl. 11), by the execution of more ambitious, large-scale commissions. In these works we discern a new point of reference for Niccolò's idiom in the art of his slightly older contemporary Bartolo di Fredi, who held a virtual monopoly over the production of monumental

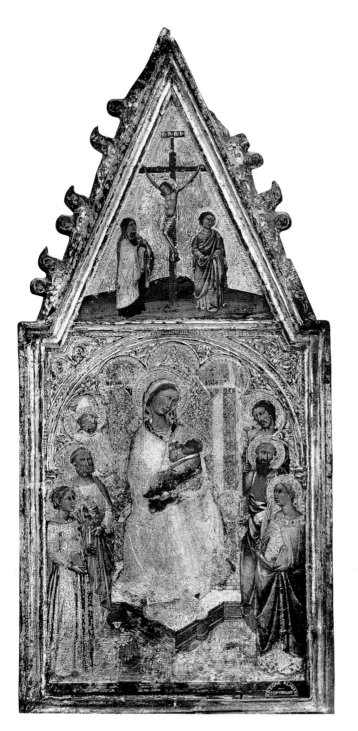

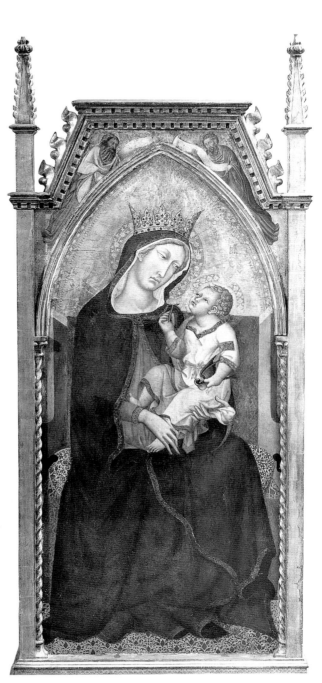

57. Niccolò di Buonaccorso, *Virgin and Child with Sts. Lucy, Peter, Nicholas of Bari, Catherine of Alexandria, Paul, and James.* Pinacoteca Nazionale, Siena. Photo courtesy of Alinari/Art Resource, New York

58. Bartolo di Fredi, *Virgin and Child.* Galleria Corsi, Palazzo Bardini, Florence

altarpieces in Siena throughout the 1380s. Prior to its identification by Boskovits, in fact, the central panel of the Costalpino altarpiece, which by the time it entered the Kisters collection in Kreuzlingen had been deprived of its frame with the accompanying signature and date, had been generally regarded as a work of Bartolo di Fredi.[114] Indeed, it is in the works executed by Bartolo in the first half of the 1380s, as recently noted by Freuler, that we find the closest analogies for the Kisters *Madonna,* whose style and composition may have been directly inspired by an image such as the full-length Madonna and Child in the Corsi collection, Florence (fig. 58), where we encounter the same poses and the motif of the Christ Child offering a rose to the Virgin.[115] Equally indebted to Bartolo di Fredi's vocabulary as reflected in this image is a noticeable hardening of the outlines and narrowing of the facial features that separate the execution of the Kisters *Madonna* from Niccolò's earlier production. The same qualities characterize the full-length figure of St. Lawrence that originally flanked the Kisters *Madonna* (fig. 59), whose stern countenance and rigid proportions reflect a significant departure from the gentler pose and open features of the same figure portrayed by the artist at an earlier date, in the fragment presently in the Glasgow Art Gallery (fig. 54).

Entirely typical of Niccolò's idiom, however, are the brilliant decorative surface effects and sophisticated spatial concerns that ultimately distinguish the Kisters *Madonna* from Bartolo di Fredi's production. Whereas in the Corsi *Madonna* the simply articulated throne structure all but disappears behind the sumptuous brocade cloth and the ample draperies of the Virgin, in the Kisters *Madonna* it becomes an integral part of the composition, occupying the full height of the picture surface and articulating it in depth. The fanciful architectural elements of the throne and the irregular outline of the platform on which it stands, moreover, lend a dynamic quality to the space, that contrasts with the essentially static character of Bartolo's image.

Although nothing is known of the early provenance of the Costalpino altarpiece, the fact that the figure of St. Lawrence was repainted to transform it into a St. Margaret suggests that it was not originally intended for the church of Santa Margherita at Costalpino, but was transferred there from a nearby location. The presence of a nun dressed in a black, possibly Augustinian habit among the small donors represented at the feet of St. Lawrence raises

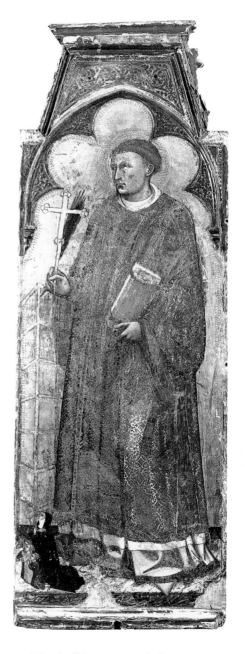

59. Niccolò di Buonaccorso, *St. Lawrence.*
Pinacoteca Nazionale, Siena

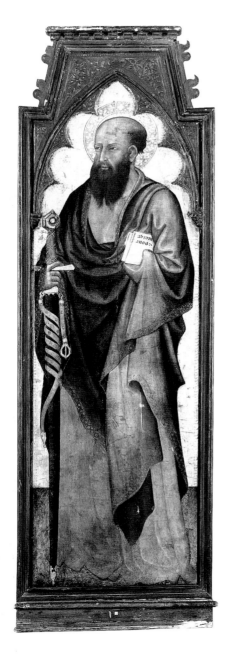

60. Niccolò di Buonaccorso, *St. Paul.*
The Metropolitan Museum of
Art, New York, Gift of George
Blumenthal (1941). 41.190.531

the possibility that the work may instead have been com-
missioned for an altar in the Augustinian convent of Santa
Maria Maddalena, no longer extant, outside Porta Tufi, not
far from Costalpino and Montecchio. Founded in 1339 by
a certain Margherita di Sanese di Benedetto da Siena—per-
haps identifiable with the nun in the painting—this convent
was to become one of the wealthiest and largest female
houses in Sienese territory, enjoying special privileges from
the Sienese Commune and eventually attracting to its pre-
mises nuns from other institutions who also took on the
Augustinian habit.[116] After the convent's destruction in
1526, it is possible that Niccolò's altarpiece, if indeed com-
missioned for it, was entrusted with other works of art to
the care of the monks of the homonymous Augustinian
monastery of Santa Maria Maddalena in Montecchio, who
held under their jurisdiction the church of Sant'Andrea
a Montecchio.[117] Sometime about 1567, when Santa
Margherita at Costalpino was annexed to the parish of
Sant'Andrea a Montecchio,[118] the painting may have been
transferred from the monastery of Santa Maria Maddalena
to the church of Santa Margherita, and the figure of St.
Lawrence repainted in accordance with its dedication.

About the same date as the Costalpino altarpiece,
Niccolò appears to have been entrusted with the commis-
sion for another large-scale polyptych, of which the only
surviving fragment is a full-length St. Paul in the Metro-
politan Museum of Art, New York (fig. 60). First recog-
nized as a work of Niccolò by Boskovits,[119] this image
bears close comparison to the figures from the Costalpino
altarpiece, with which it shares the same austere counte-
nance and proportions as well as the sharp outlines and
narrow facial features. Similar analogies may be drawn be-
tween the head of St. Paul and the fragmentary head of a
large scale Madonna by Niccolò, in the Städelsches Kunst-
institut in Frankfurt (fig. 61), that perhaps originally
formed part of the same complex.[120]

Despite the demands placed on his workshop, Nic-
colò's production of small devotional altarpieces during
these years is marked by the continued reelaboration of
compositional formulae and motifs into exquisitely refined
works such as the *Madonna and Child Enthroned with a Bishop
Saint, St. John the Baptist, and Four Angels* in the Museum
of Fine Arts, Boston (fig. 62), that was originally the cen-
tral panel of a portable triptych. Although Kanter has
placed the date of execution of this work about or just

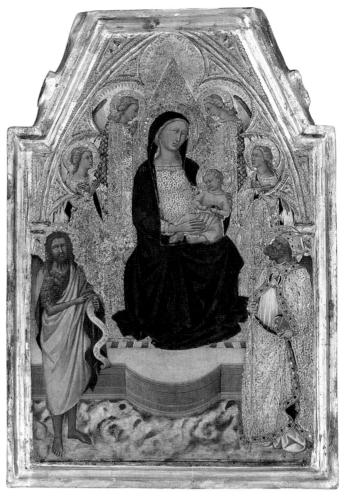

61. Niccolò di Buonaccorso, *Fragment of Virgin's Head.*
Städelsches Kunstinstitut, Frankfurt

62. Niccolò di Buonaccorso, *Madonna and Child Enthroned with a
Bishop Saint, St. John the Baptist, and Four Angels.* Museum of
Fine Arts, Boston, Gift of Mrs. Thomas O. Richardson

before 1380, contemporary to the Uffizi-National Gallery-Lehman complex,[121] a slightly later dating is suggested by its greater proximity to other works generally viewed as closer to the 1385 Biccherna cover and 1387 Costalpino altarpiece, such as the Frankfurt Madonna or the Virgin of Humility in the Louvre, where we find the same type of Virgin and ebullient Christ Child.[122] The composition of the Boston panel, as first pointed out by Meiss, represents a more elaborate version of a slightly earlier image of the Virgin and Child, in the central panel of a triptych by Niccolò in the National Gallery, Prague (fig. 63), which includes a similarly shaped and sumptuously gilt throne, as well as the same type of platform.[123] A third version of this composition, closer in date to the Boston picture, but more ambitious in its spatial complexity, is the Enthroned Virgin and Child with Six Saints and Two Angels in the Gemäldegalerie, Berlin (fig. 64),[124] in which a greater sense of depth is achieved by the extension of the platform along

the sides of the panel and the substitution of the gilt throne with an elaborately painted architectural structure recalling that of the Costalpino altarpiece. A detail that once again attests to the use of a pattern book in creating these versions is the virtual correspondence in placement, appearance, and pose between the pair of angels behind the throne in the uppermost section of the Boston painting and those in Berlin.

The repetition of motifs and compositional devices in Niccolò's production throughout his brief career has frequently led to a confusion between those images that clearly reflect the master's own hand and others that may more properly be considered the product of his workshop. Close examination of other works datable to the second decade of Niccolò's career suggests, in fact, that in addition to facilitating his own work, the use of model books allowed Niccolò to entrust the actual execution of replicas and variations of his designs to studio assistants. One instance

Pl. 13a NICCOLÒ DI BUONACCORSO AND ASSISTANT
Annunciation, ca. 1380
Tempera and gold on wood, 39 × 25.3 cm (15¼ × 10 in.)
Wadsworth Atheneum, Hartford, The Ella Gallup Sumner and
Mary Catlin Sumner Collection Fund, 1951.94

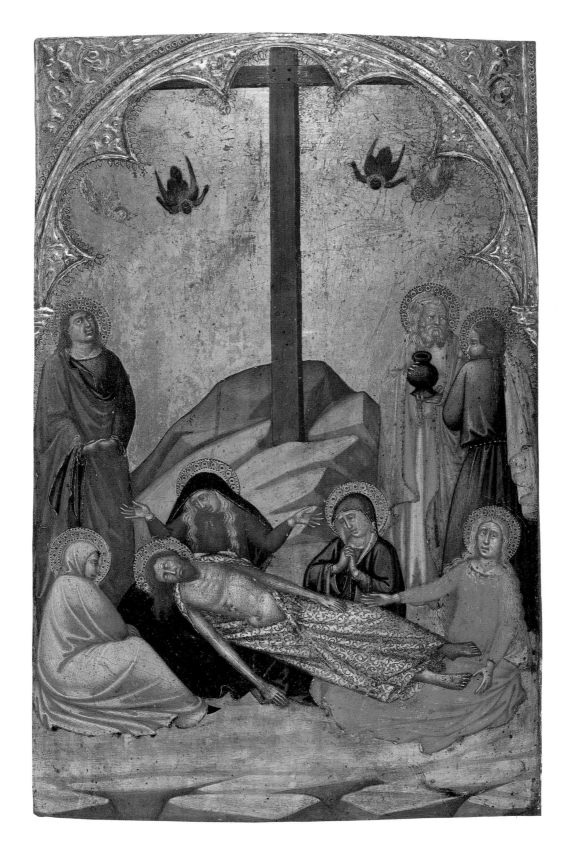

Pl. 13b ASSISTANT OF NICCOLÒ DI BUONACCORSO
Lamentation, ca. 1380
Tempera and gold on wood, 41 × 26.7 cm (16⅛ × 10½ in.)
The Metropolitan Museum of Art, New York, Robert Lehman Collection.
(1975.1.20)

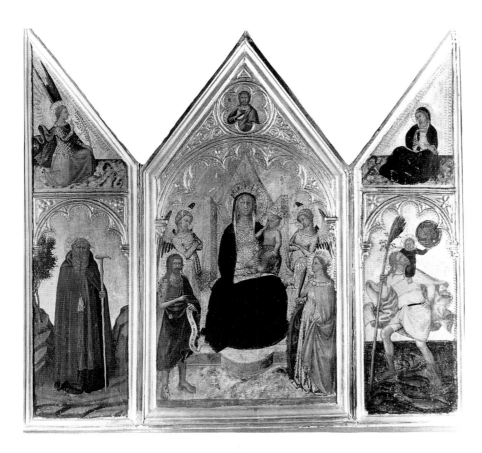

63. Niccolò di Buonaccorso, *Virgin and Child with Sts. John the Baptist and Catherine of Alexandria, and Two Angels; Sts. Anthony Abbott and Christopher.* National Gallery, Prague

64. Niccolò di Buonaccorso, *Virgin and Child with Sts. Peter, a Female Martyr, John the Baptist, Paul, Lucy, and Anthony Abbott, and Two Angels.* Gemäldegalerie, Berlin. Photo courtesy of the Institute of Fine Arts, New York University, Richard Offner Collection

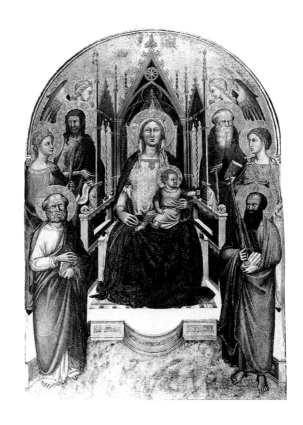

of such workshop intervention is represented by a small diptych with the Annunciation and Lamentation, presently divided between the Wadsworth Atheneum in Hartford and the Lehman Collection in the Metropolitan Museum of Art, New York (pl. 13a, b). Although the elaborate architectural setting and spatial accomplishment of the Hartford *Annuciation* (pl. 13a), which find a close precedent in the Uffizi and National Gallery panels, have led some scholars to consider this work among Niccolò's autograph production,[125] the stiffer handling of the figures and draperies and the coarsely defined facial types, especially noticeable in the Lehman *Lamentation* (pl. 13b), confirm the initial doubts raised by Berenson concerning its attribution and suggest that it should rather be viewed as the product of an assistant working over the master's cartoon.[126] The same hand may perhaps be identified in the execution of the New Testament scenes in the upper registers of a portable altarpiece in the Pinacoteca Nazionale, Siena (fig. 65), as well as in a little-known *Crucifixion* formerly in the Wallraf-Richartz-Museum, Cologne (fig. 66),

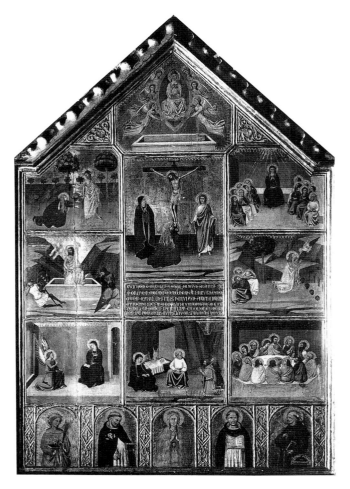

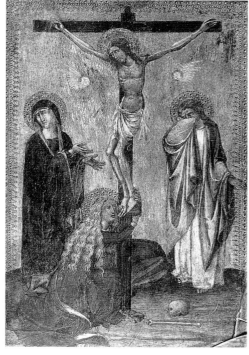

65. Workshop of Niccolò di Buonaccorso, *New Testament Scenes with Sts. Catherine of Alexandria (?), Dominic, Mary Magdalen, Thomas Aquinas, and Francis.* Pinacoteca Nazionale, Siena. Photo courtesy of the Institute of Fine Arts, New York University, Richard Offner Collection, and Alinari/Art Resource, New York

66. Workshop of Niccolò di Buonaccorso, *Crucifixion.* Ex-Wallraf-Richartz-Museum, Cologne. Photo courtesy of the Institute of Fine Arts, New York University, Richard Offner Collection

first attributed to a follower of Niccolò by Meiss, and characterized by virtually identical figural types with large expressive hands and exaggerated gestures like those found in the Lehman *Lamentation.*[127]

Similar attributional problems are encountered in the evaluation of those works produced by less accomplished, minor imitators of Niccolò's style and compositional formulae, such as the so-called Master of Panzano. Named after his most ambitious endeavor, a large triptych with the Mystic Marriage of St. Catherine with Sts. Peter and Paul, in the church of San Leolino a Panzano (fig. 67), in the Sienese Chianti region, this artist was first identified by Bernard Berenson as the anonymous author of a stylisti-

cally homogeneous group of small panels for private devotion that included a portable triptych in the Walters Art Gallery, Baltimore (fig. 68), and a panel in the collection of the Monte dei Paschi, Siena (fig. 69).[128] On the basis of these works, to which he later added, among others, a large *Virgin and Child* in the Museo Civico, Montalcino (fig. 70), purportedly dated 1372, Berenson characterized this master as a minor follower of Paolo di Giovanni Fei, influenced by Barna da Siena, Bartolo di Fredi, and Andrea Vanni.[129]

While generally accepting Berenson's identification of the Master of Panzano as a distinct personality in Sienese painting of the second half of the fourteenth century,

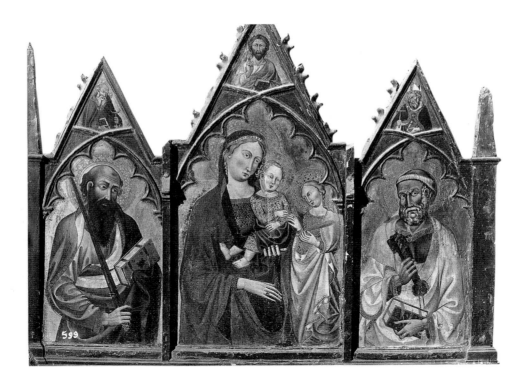

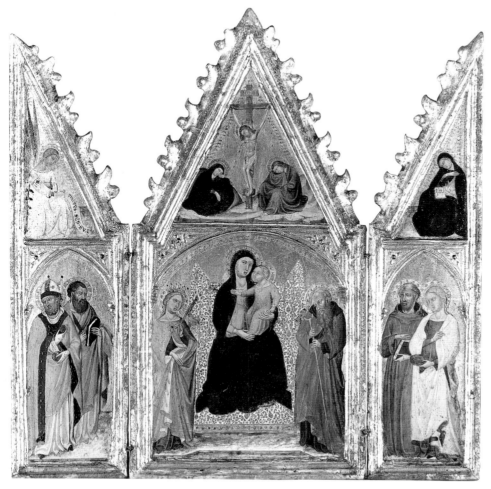

67. Master of Panzano, *Mystic Marriage of St. Catherine with Sts. Peter and Paul.* Pieve di San Leolino, Panzano. Photo courtesy of the Institute of Fine Arts, New York University, Richard Offner Collection

68. Master of Panzano, *Virgin and Child with Sts. Catherine of Alexandria and Anthony Abbott; Nicholas of Bari and Bartholomew; Lucy and Francis.* The Walters Art Gallery, Baltimore

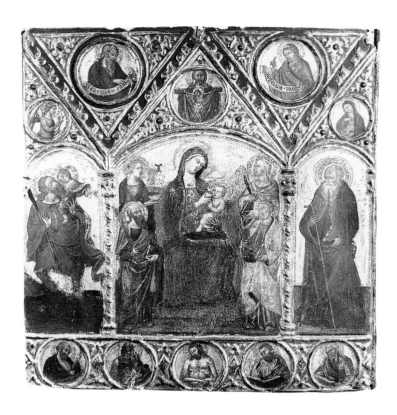

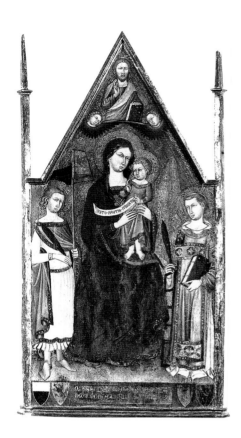

69. Master of Panzano, *Virgin and Child with Sts. Paul, Lucy, Peter, and Catherine of Alexandria; Christopher; Anthony Abbott.* Monte dei Paschi Collection, Siena. Photo courtesy of the Institute of Fine Arts, New York University, Richard Offner Collection, and Alinari/Art Resource, New York

70. Master of Panzano, *Virgin and Child with Sts. Ansanus and Lawrence.* Museo Civico, Montalcino. Photo courtesy of the Institute of Fine Arts, New York University, Richard Offner Collection

subsequent scholars have been divided over the precise outlines of his career and the exact formation of his idiom. According to Fehm, who placed the artist's activity between about 1365 and 1380, the dominant influence on the artist's style as well as on his compositional motifs was the contemporary production of Luca di Tommè, who at one time may actually have employed the painter as an assistant in his workshop.[130] In the most comprehensive study of the Master of Panzano to date, on the other hand, Denise Boucher de Lapparent proposed a later chronology for his activity, between 1380 and 1400. Although she also perceived the influence of Luca di Tommè on the artist's compositional formulae, Boucher de Lapparent discerned the roots of his style in the production of Bartolo di Fredi, Paolo di Giovanni Fei, and Niccolò di Buonaccorso.[131] Contemporary to Boucher de Lapparent's study was Gordon Moran's not entirely convincing effort to identify

the Master of Panzano with the little-known Sienese painter Francesco di Vannuccio, whose production has also sometimes been confused with that of Niccolò di Buonaccorso and Paolo di Giovanni Fei.[132]

Datable to the period of the Panzano Master's strongest adherence to Luca di Tommè's models are the Montalcino altarpiece and three large fragments from an unidentified polyptych first attributed to the artist by Berenson, showing the Virgin and Angel of the Annunciation (private collection; fig. 71) and St. Nicholas of Tolentino (The Toledo Museum of Art; fig. 72).[133] As noted by Fehm, these images reveal significant points of contact with Luca's mature production of the late 1360s and early 1370s, in particular as represented by the signed and dated 1366 *Crucifixion* in the Museo Nazionale di San Matteo, Pisa (fig. 27), whose structure and compositional format are recalled in the Montalcino altarpiece; and by two large panels with the Angel

and Virgin of the Annunciation, formerly in a private collection, Paris, of which the Panzano Master's images constitute a slightly reduced, simplified version.[134] Further comparisons may be drawn between the gestures and poses of the Virgin and Child in the Montalcino altarpiece and the central panel of Luca's altarpiece in the church of San Francesco in Mercatello sul Metauro, in the Marches, also datable to the late 1360s and early 1370s.[135]

If these works betray the Panzano Master's familiarity with Luca di Tommè's compositional models, they are more closely related stylistically to Bartolo di Fredi's essentially calligraphic approach. The influence of Bartolo di Fredi on the Panzano Master's formation is evidenced by a polyptych in the town hall in Seggiano, near Grosseto, generally considered among the artist's earliest efforts, but only slightly predating the Montalcino altarpiece.[136] The strong linear accents and austere physiognomic types that characterize the figures in these panels find a close point of reference in the large-scale altarpieces executed by Bartolo di Fredi in Montalcino in the early to mid-1380s. The image of St. Catherine of Alexandria in the outermost

right-hand compartment of the Seggiano polyptych, for example, corresponds closely, in both pose and execution, to Bartolo's representation of the same saint in a panel in the Perkins collection, Assisi,[137] originally included, perhaps above the Corsi *Madonna,* in an altarpiece for the church of Sant'Agostino in Montalcino, dated by Freuler between 1380 and 1385.[138] Defined by a looser, more cursive drawing style and heightened expressivity vis-à-vis both the Seggiano and Montalcino altarpieces, the triptych in the Pieve di San Leolino at Panzano—with which Boucher de Lapparent convincingly associated a predella fragment in the Horne Museum, Florence (fig. 73)—marks a later phase in the artist's career, more closely allied to Bartolo di Fredi's production in the last decade of his career.

Beginning with the Baltimore triptych (fig. 68), the earliest of the Panzano Master's small-scale devotional panels are equally indebted to the production of Bartolo di Fredi, closely recalling the vocabulary of his small narrative scenes, as represented by the panels that originally flanked the Coronation of the Virgin altarpiece in Montalcino, executed between 1383 and 1388.[139] One of the scenes

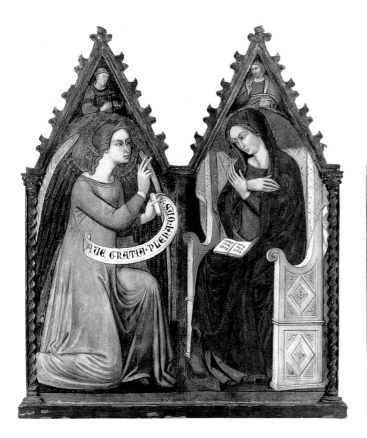

71 (left). Master of Panzano, *Annunciation.* Private collection

72 (right). Master of Panzano, *St. Nicholas of Tolentino.* The Toledo Museum of Art, Gift of Paul Reinhardt in memory of his father, Henry Reinhardt. Photo courtesy of the Institute of Fine Arts, New York University, Richard Offner Collection

formerly included in this altarpiece, an *Adoration of the Magi,* now property of the National Trust at Polesden Lacey, for example, reflects such close affinities with the Panzano Master's production that it was originally published by Berenson among the latter's oeuvre.[140] Similarly, images that are datable to a later phase in the Panzano Master's career, such as the triptych in the Monte dei Paschi (fig. 69) and the much ruined *Mystic Marriage of St. Catherine* in the Faculté de Médecine, Paris, first attributed to him by Boucher de Lapparent,[141] exemplify the artist's dependence on the lively, expressionistic quality of Bartolo's latest works.

While generally reflecting the Panzano Master's continued adherence to Bartolo di Fredi's idiom, his small-scale production also finds significant points in common with the work of Niccolò di Buonaccorso. Derived from Niccolò are the miniaturist quality of execution of these images, characterized by the same brilliant coloristic effects and profusion of gold surfaces, as well as certain compositional formulae, albeit greatly simplified and lacking Niccolò's sophisticated spatial sense. Such similarities would not necessarily warrant positing a direct contact of one artist with the other were it not for the fact that included among the Panzano Master's generally accepted oeuvre are several images of a noticeably higher quality

73. Master of Panzano, detail of Panzano altarpiece predella: *St. James.* Horne Museum, Florence. Photo courtesy of the Institute of Fine Arts, New York University, Richard Offner Collection

of execution, which have often led to a confusion between the two personalities: two pairs of standing saints, originally the wings of a portable altarpiece, in the Pinacoteca Vaticana, Rome (fig. 74); and two fragments from a similar complex, with pairs of standing saints painted on both sides, in the San Diego Museum of Art (pl. 14a, b). Generally attributed to Niccolò di Buonaccorso and compared specifically to the standing figures in the latter's panels in the Pinacoteca Nazionale, Siena, and in the Museum of Fine Arts, Boston (figs. 57 and 62), the saints in the Pinacoteca Vaticana were first given to the Panzano Master by Boucher de Lapparent, followed by Boskovits.[142] While undoubtedly related to Niccolò's figures, with which they share significant morphological and decorative aspects, the Vatican saints are nevertheless distinguished by a broader execution and less meticulous attention to detail, traits that are in effect more typical of the Master of Panzano's approach as reflected in the figures in the Baltimore triptych or in the predella of the Panzano triptych (figs. 68, 73).

The possibility that the Vatican panels might actually be a result of the Panzano Master's intervention over a design by Niccolò is suggested by consideration of this work in light of the evidence provided by the double-sided panels in San Diego (pl. 14a, b), which, though generally attributed to the Master of Panzano,[143] in fact represent the effort of two distinct hands, one of which may be identified with Niccolò di Buonaccorso. Clearly related to the production of the Panzano Master are the pairs of standing saints—James and Anthony Abbott, Francis and Ansanus—painted on the front of what originally constituted the lateral wings of this portable altarpiece (pl. 14a). Indeed, these find their closest point of reference in the Panzano triptych itself and its accompanying predella (figs. 67 and 73), as well as in the large grisaille figures in the Museo Nazionale di San Matteo, Pisa, first attributed to the artist by Boucher de Lapparent.[144] The loosely calligraphic, hurried quality that characterizes the execution of these works—like that of the Vatican saints—appears in marked contrast, however, to the more sophisticated spatial and formal approach that is reflected in the grisaille images of Sts. Anthony Abbott and Christopher on the reverse of the San Diego panels (pl. 14b). These elongated figural types with precisely modeled features and brilliant pupils, and their spatial arrangement in carefully articulated niches cast in light and shadow, recall instead the more refined

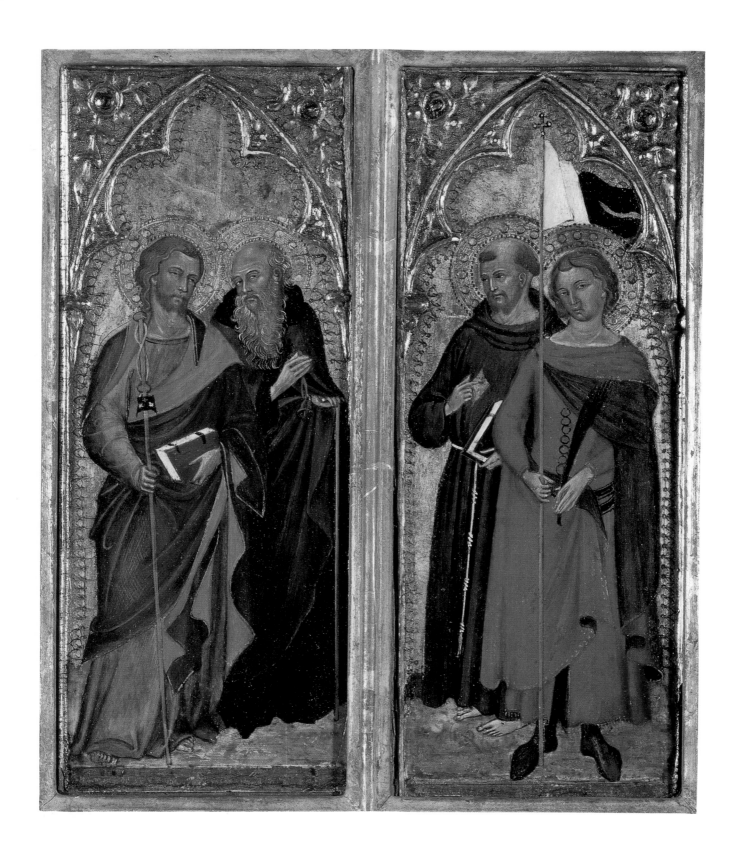

Pl. 14a MASTER OF PANZANO
Lateral wings from a portable altarpiece: recto, *Sts. James and Anthony Abbott,
and Sts. Francis and Ansanus,* ca. 1385–90
Tempera and gold on wood, each panel, 26.7 × 10.4 cm (10½ × 4⅛ in.)
San Diego Museum of Art: Gift of Misses Anne R. and Amy Putnam, 1946:019

Pl. 14b NICCOLÒ DI BUONACCORSO
Lateral wings from a portable altarpiece: verso, *Sts. Anthony Abbott and Christopher,* ca. 1385–90
Tempera and gold on wood, each panel, 26.7 × 10.4 cm (10½ × 4⅛ in.)
San Diego Museum of Art: Gift of Misses Anne R. and Amy Putnam, 1946:019

74. Master of Panzano, *Sts. Anthony Abbot and Francis; Paul and Nicholas of Bari.* Pinacoteca Vaticana, Rome. Photo courtesy of Alinari/Art Resource, New York

vocabulary of Niccolò di Buonaccorso, in particular as reflected in late works, such as the Berlin *Maestà* (fig. 64), or the virtually contemporary predella with scenes from the Life of St. Anthony Abbott, in the Museum of Fine Arts, Houston (fig. 75).[145]

The combined evidence provided by the Vatican and San Diego panels suggests a possible affiliation between the Panzano Master and Niccolò di Buonaccorso, perhaps as collaborators in the older artist's workshop. The isolated nature of these instances of mutual participation on the same commission might be explained by the dating of their collaboration to the last years of Niccolò's activity, after whose death the Master of Panzano appears in effect to have inherited his prominent role, in Siena and its surrounding provinces, in the production of small panels for private devotion. In view of the possibility of such an affiliation with Niccolò, it may be tempting to identify the Master of Panzano with that Paolo di Buonaccorso di Pace,

perhaps a younger brother of Niccolò, who is mentioned as an associate of Luca di Tommè in a Biccherna document dated 1374,[146] loosely coinciding with the period of the Panzano Master's noted adherence to the latter's compositional models. Were such to prove the case, it might be speculated that after a separate career passed in the orbit of Bartolo di Fredi and Luca di Tommè, Paolo di Buonaccorso might either have briefly joined his more successful brother in the capacity of an assistant or, upon the latter's death, have actually inherited his practice and the contents of his studio.[147]

The problems encountered in trying to assess the precise contours of the Master of Panzano's personality are indicative of the essentially eclectic nature of his idiom which, like that of many minor masters, reflects an amalgamation of various elements derived from the dominant artistic figures of his period. In this respect, the Master of Panzano

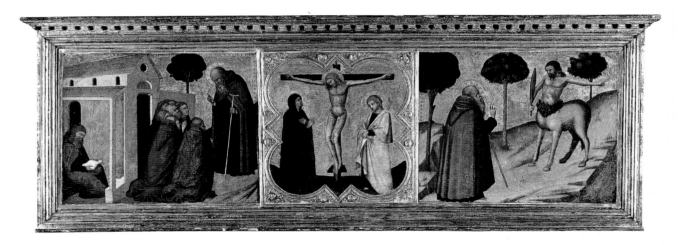

75. Niccolò di Buonaccorso, predella fragment: *St. Anthony Abbot Preaching to His Monks; Crucifixion; St. Anthony Abbott Meeting the Centaur.* The Museum of Fine Arts, Houston; The Edith A. and Percy S. Straus Collection

clearly illustrates that phenomenon of "proto-industrial" mass production of works of art for a broad domestic market outlined by Samuel Cohn. At the same time, his case should not be used as a paradigm for the evaluation of the quality and nature of artistic practice in Siena throughout the second half of the fourteenth century. As suggested in the preceding pages, artists of the caliber of Luca di Tommè and Niccolò di Buonaccorso clearly succeeded in satisfying the demands of the market by skillfully manipulating a traditional repertoire of images to create a body of works that, while perhaps not as innovative as their predecessors', are nearly their equal in formal and technical accomplishment. Viewed in the context of their production, as well as that of the Panzano Master, Sienese painting of the second half of the fourteenth century embraces many of the same issues that defined artistic activity in the first half of the century, a period dominated by major personalities, but that also witnessed the repetition of their models by innumerable minor imitators and followers.

Meiss's theory of cataclysmic change brought about by the Black Death fails to acknowledge these strong patterns of continuity, inherent in the very nature of Sienese artistic practice. If the events of 1348 had any impact on the evolution of Sienese painting, it was in the exaggeration, especially among patrons, of a conservatism always present in Siena. The evidence of such a phenomenon, however, lies more in the choices of subject and compositions re-

quired of artists than in the style in which they expressed themselves. As demonstrated by the vivaciously expressive idiom of Luca di Tommè, or the sophisticated architectural solutions of Niccolò di Buonaccorso, whose spatial concerns have been thought to anticipate the experiments carried out half a century later by Sassetta, the best Sienese artists of this period did anything but turn their backs on the achievements of their predecessors. Instead, their work reaffirms the continued vitality of the best Sienese narrative tradition from its Golden Age into the next century.

NOTES

1. Millard Meiss, *Painting in Florence and Siena after the Black Death: The Arts, Religion, and Society in the Mid-Fourteenth Century* (Princeton, N.J, 1951).

2. For a recent summary of opinions, see Diana Norman, "Change and Continuity: Art and Religion after the Black Death," in *Siena, Florence, and Padua: Art, Society, and Religion, 1280–1400*, ed. Diana Norman, 2 vols. (New Haven and London, 1995), vol. 1, pp. 177–95.

3. Samuel K. Cohn, Jr., *The Cult of Remembrance and the Black Death: Six Renaissance Cities in Central Italy* (Baltimore and London, 1992).

4. Erling S. Skaug, *Punch Marks from Giotto to Fra Angelico: Attribution, Chronology, and Workshop Relationships in Tuscan Panel Painting, with Particular Consideration to Florence, 1330–1430*, 2 vols. (Oslo, 1994).

5. Cohn, *The Cult of Remembrance*, p. 277.

6. Meiss, *Painting in Florence and Siena*, p. 21.

7. Except where otherwise noted, these and all following documentary references to Luca are quoted from the monographic study of Sherwood A. Fehm, *Luca di Tommè: A Sienese Fourteenth-Century Painter* (Carbondale, Ill., 1986), pp. 191–204.

8. Skaug, *Punch Marks*, vol. 1, pp. 234, 249.

9. Fehm, *Luca di Tommè*, p. 198, doc. 18a–b.

10. That the contract for the painting was drawn up in 1363 is also implied by the document's final statement, which refers to the decision of the General Council to commission such a work, as stated in the records of their meeting written down by their notary "at the time." It is very likely that Luca's St. Paul altarpiece was intended as a pendant to Lippo Vanni's fresco in the General Council Hall. For the commission of the frescoes, see Gabriele Borghini in Cesare Brandi et al., *Palazzo Pubblico di Siena: Vicende costruttive e decorazione* (Siena, 1983), p. 224.

11. Fehm, *Luca di Tommè*, pp. 192–93.

12. William Bowsky, *A Medieval Italian Commune: Siena under the Nine, 1287–1355* (Berkeley, 1981), pp. 189–90. As Bowsky observes, these voluntary loans were not without their reward, since they generated handsome profits as well as preferential treatment from the Commune.

13. It should be noted that no system determining the order in which artists signed the lists is specified within the guild rules themselves. However, circumstantial documentary evidence does suggest that precedence was accorded to an artist's age or seniority. See Fehm, "Notes on the Statutes of the Sienese Painters Guild," *Art Bulletin* 54 (June 1972): 198–200.

14. Laurence B. Kanter, in Timken Museum of Art, *European Works of Art, American Paintings, and Russian Icons in the Putnam Foundation Collection* (San Diego, 1996), p. 28. Although the 1356 date of the statutes is still generally applied to the painters' roll by most authors (except for Giulietta Chelazzi Dini, who raises some doubts in *Il gotico a Siena: miniature, pitture, oreficerie, oggetti d'arte*, exh. cat., Palazzo Pubblico [Siena, 1982], p. 276), the parameter of dates proposed by Kanter is an accurate reflection of 1) the fact that the name of Bartolomeo Bulgarini, who was active by 1338 and died in 1378, is not included in this list although he did sign another securely dated roll of 1363, and 2) the fact that the name of Biagio di Goro, who died in 1386, is included.

15. Orlando Malavolti, *Dell'historia di Siena* (Siena, 1599; Bologna, 1982), pt. 2, bk. 8, p. 153r.

16. For a discussion of this second list, which includes many of the same names from the previous roll, see Fehm, "Notes on the Statutes"; *Luca di Tommè*, p. 194.

17. Malavolti, *Dell'historia di Siena*, pt. 2, bk. 9, p. 170v.

18. Federico Zeri, "Sul problema di Niccolò Tegliacci e Luca di Tommè," *Paragone*, no. 105 (1958): 3–16.

19. This proposal was first made in oral communication by Gordon Moran, as quoted by Cristina De Benedictis, *La pittura senese, 1330–1370* (Florence, 1979); Fehm, *Luca di Tommè*, p. 18 n. 10; Henk van Os, *Sienese Altarpieces, 1215–1460: Form, Content, Function*, vol. 2, *1344–1460* (Groningen, 1990), pp. 45–46.

20. Zeri, "Sul problema di Niccolò Tegliacci e Luca di Tommè," pp. 5–8; De Benedictis, *La pittura senese*, pp. 52–54; Piero Torriti, *La Pinacoteca Nazionale di Siena* (Genoa, 1990), pp. 100–101.

21. Millard Meiss, "Notes on Three Linked Sienese Styles," *Art Bulletin* 45 (March 1963): 47–48; Fehm, *The Collaboration of Niccolò Tegliacci and Luca di Tommè*, J. Paul Getty Museum Publication, no. 5 (Los Angeles, 1973), pp. 20–26; Chelazzi Dini, in *Il gotico a Siena*, p. 276; Fehm, *Luca di Tommè*, pp. 18–20; Gaudenz Freuler, *"Manifestatori delle cose miracolose": Arte italiana del '300 e '400 da collezioni in Svizzera e nel Liechtenstein*, exh. cat., Villa Favorita (Lugano, 1991), p. 65.

22. The mistake was first pointed out by Gordon Moran and Sonia Fineschi, "Niccolò di Ser Sozzo—Tegliacci or di Stefano?" *Paragone*, no. 321 (1976): 58–63, who published a series of documents showing that Sozzo di Francesco Tegliacci never had a son named Niccolò. They suggested that the painter was in all likelihood the son of the notary and miniaturist Ser Sozzo di Stefano, who is known only through documents between 1293 and 1321.

23. See Carla Zarrilli and Giulietta Chelazzi Dini, in *Il gotico a Siena*, pp. 236–38, with previous bibliography.

24. Gaetano Milanesi, *Documenti per la storia dell'arte senese*, 3 vols. (Siena, 1854), vol. 1, p. 50.

25. For a summary of these documents, see Cesare Brandi, "Niccolò di Ser Sozzo Tegliacci," *L'Arte* 3 (1932): 223–36.

26. De Benedictis, *La pittura senese*, p. 11; Chelazzi Dini, in *Il gotico a Siena*, pp. 236–38.

27. Meiss, *Painting in Florence and Siena*, p. 169; Fehm, *Luca di Tommè* (as in n. 7), pp. 16–17; Skaug, *Punch Marks* (as in n. 4), vol. 1, pp. 241–43.

28. Chelazzi Dini, in *Il gotico a Siena* (as in n. 14), pp. 243–44.

29. Margaret E. Frazer, "Medieval Church Treasures," *The Metropolitan Museum of Art Bulletin* 43, no. 3 (Winter 1985–86): 42–43. The initial *V* illustrates the text of the second response of the first nocturne for the Feast of the Assumption: "Vidi speciosam sicut columbam ascendentem desuper rivos aquarum cuius inextimabilis odor erat nimis in vestimentis eius" (I saw her, fair as a dove, taking flight over running waters; and a priceless perfume permeated her garments). The book from which this page was cut remains to be identified.

30. Cristina De Benedictis, "I corali di San Gimignano—le miniature di Niccolò Tegliacci," *Paragone*, no. 313 (1976): 112, 117–18 n. 26, attributed the Lehman cutting to an assistant of Niccolò. For a full discussion of it in the context of Niccolò's entirely autograph miniature production, see the entry by the present author and Mirella Levi d'Ancona in the forthcoming catalogue of manuscript illuminations in the Robert Lehman Collection. As pointed out in that entry, the initial *V* illustrates the text of the response at Matins for the Feast of the Ascension: "Viri Galilei quid aspicitis in Caelum?" (Men of Galilee, why do you stand looking up to heaven?). Still visible on the reverse of the cutting is a fragment of the

complementary versicle to the third Matins response for the Feast of the Ascension: "[Cumque intuerentur in caelum euntem] illum, ecce duo [viri astiterunt iu]xta illos i[n] vesti[bus albis, qui et dixerunt]" (And while they were gazing up to heaven as He went, behold, two men stood by them in white garments, and said to them). As with the Metropolitan Museum illumination, the original provenance of the Lehman cutting is unknown.

31. Skaug, *Punch Marks,* vol. 1, pp. 240–43. Skaug's conclusion that the predominance of punches by Ambrogio are an indication that Niccolò was trained exclusively by him is not supported, however, by stylistic evidence which, as noted above, confirms the overriding influence of Pietro. For technical evidence of Niccolò's particular debt to Pietro, see Norman E. Muller, "Three Methods of Modeling the Virgin's Mantle in Early Italian Painting," *Journal of the American Institute for Conservation* 17 (1978): 14.

32. The altarpiece was originally located in the parish church of Santa Maria di Monteoliveto at Barbiano (province of San Gimignano), a monastery built by the monks of Monteoliveto Maggiore on land bequeathed to them for that purpose in 1340, under the terms of the will of Giovanni di Gualterio Salucci, a nobleman from San Gimignano. Emanuele Repetti, *Dizionario geografico fisico storico della Toscana,* 6 vols. (Florence, 1833–46), vol. 1, pp. 271–72, vol. 5, p. 48; De Benedictis, *La pittura senese,* p. 24; Fehm, *Luca di Tommè,* p. 17; Van Os, *Sienese Altarpieces,* pp. 142–45.

33. Tatyana K. Kustodieva, *The Hermitage, Catalogue of Western European Paintings: Italian Paintings, Thirteenth to Sixteenth Centuries* (Moscow and Florence, 1994), p. 321, no. 173.

34. Luisa Marcucci, *Gallerie Nazionali di Firenze: i dipinti Toscani del secolo XIV* (Rome, 1965), pp. 168–69, no. 116.

35. Just one of Niccolò's known panel paintings, a *Madonna and Child* formerly in a private collection in Milan, known to me only through photographs, however, still appears to reflect the soft contours and rounded forms of the artist's miniature production, suggesting a contemporary dating. Fehm, *Collaboration,* fig. 11.

36. Fehm, *Collaboration,* p. 29 n. 15; Fehm, *Luca di Tommè,* p. 25.

37. Fehm, "Attributional Problems Surrounding Luca di Tommè," in *Essays Presented to Myron P. Gilmore,* 2 vols. (Florence, 1978), vol. 2, p. 157.

38. Fehm, *Luca di Tommè,* p. 25 and cat. 67.

39. Laurence B. Kanter, *Italian Paintings in the Museum of Fine Arts, Boston* (Boston, 1994), pp. 100–103, cat. 19, with previous biliography.

40. The National Museum of Western Art Tokyo, *Catalogue of Paintings* (Tokyo, 1979), p. 9, no. 16; Pierluigi Leone de Castris, "Problemi Martiniani Avignonesi: il 'Maestro degli angeli ribelli', i due Ceccarelli ed altro," in *Simone Martini: Atti del Convegno,* ed. Luciano Bellosi (Florence, 1988), pp. 226–28. I find that the pronounced Lorenzettian qualities evidenced by the plastic modeling of this figure have little to do with the more decorative idiom of Simone Martini, or any of his supposed followers.

41. The Palazzo Pubblico *Annunciation* was recently attributed to Luca by Miklós Boskovits, *The Thyssen-Bornemisza Collection: Early Italian Paintings, 1290–1470* (London, 1990), p. 129 n. 14.

42. Fehm, *Luca di Tommè,* pp. 7–8.

43. Chelazzi Dini, in *Il gotico a Siena,* p. 278, cat. 102, with previous bibliography.

44. Although Chelazzi Dini's attribution is accepted by L. Borgia et al., *Le biccherne: tavole dipinte delle magistrature senesi* (Rome, 1984), and Kanter,

in Timken Museum of Art (as in n. 14), p. 28, the panel is not mentioned either in Fehm, *Luca di Tommè,* or in Skaug, *Punch Marks,* vol. 1, pp. 244–49.

45. Carlo Volpe, *Pietro Lorenzetti* (Milan, 1989), pp. 158–59, no. 128.

46. In a chapter entitled "From Narrative to Ritual," Meiss, *Painting in Florence and Siena* (as in n. 1), pp. 16–20, discusses the post-plague transformations in the depiction of this scene, using Taddeo Gaddi's very same composition, painted about 1330, as a parameter of pre-plague, Giottesque naturalism.

47. Fehm, *Luca di Tommè,* pp. 10–11.

48. See in particular the small tabernacles produced in Duccio's workshop (Pinacoteca Nazionale, Siena, no. 35) and by followers such as the Monteoliveto Master (The Metropolitan Museum of Art, New York, 18.117.1).

49. Meiss, *Painting in Florence and Siena,* pp. 34–35.

50. Ibid., p. 35.

51. Fehm, *Luca di Tommè,* pp. 11–12.

52. Kanter, in Timken Museum of Art, pp. 31–32.

53. For a full discussion of Bonaventure's departure from Augustinian thought on the Trinity and Incarnation, and the influence of St. Francis on the development of Bonaventure's own ideas, see Gabriele Panteghini, in *Teologia e filosofia nel pensiero di S. Bonaventura* (Brescia, 1974), pp. 11–54, esp. 14–18.

54. Boskovits, *The Thyssen-Bornemisza Collection* (as in n. 41), pp. 126–29, cat. 20; Freuler, "*Manifestatori delle cose miracolose*" (as in n. 21), pp. 65–67, cat. 17 (with previous bibliography).

55. Fehm, *Luca di Tommè,* pp. 12–13, 66–67, no. 5; Jetske Homan van der Heide, in H. W. van Os et al., *The Early Sienese Paintings in Holland* (The Hague, 1989), pp. 94–97, cat. 23, with previous bibliography; Boskovits, *The Thyssen-Bornemisza Collection,* p. 128. No other elements from this predella have yet been identified.

56. Fehm, *Luca di Tommè,* pp. 14, 72–74, cats. 8–9.

57. Kustodieva, *The Hermitage: Italian Paintings* (as in n. 33), p. 241, cat. 128.

58. Fehm, *Luca di Tommè,* p. 21.

59. Ibid., *Luca di Tommè,* p. 20; Boskovits, *The Thyssen-Bornemisza Collection,* p. 128.

60. Fehm, *Luca di Tommè,* pp. 26–29, cats. 15–17.

61. Van Os's suggestion (*Sienese Altarpieces* [as in n. 19], pp. 46–47) that the *Assumption* might actually have been part of the 1362 polyptych deserves further consideration.

62. Fehm, *Luca di Tommè,* pp. 31–36, 93–94, cat. 19, 98–100, cat. 22.

63. Ibid., pp. 44–47, cats. 39–42; Torriti, *La Pinacoteca Nazionale di Siena* (as in n. 20), pp. 108–9.

64. Boskovits, *The Thyssen-Bornemisza Collection,* pp. 128–29 n. 11.

65. For the attributional history of these panels, see Torriti, *La Pinacoteca Nazionale di Siena,* pp. 108–9, with previous bibliography.

66. Zeri, "Sul problema di Niccolò Tegliacci e Luca di Tommè" (as in n. 18), p. 16; De Benedictis, *La pittura senese,* pp. 38, 87–90; Chelazzi Dini, in *Il gotico a Siena* (as in n. 14), p. 276; Freuler, in *Master Paintings 1350–1800,* exh. cat., P. & D. Colnaghi & Co. (London, 1989), p. 14; Torriti, *La Pinacoteca Nazionale di Siena,* pp. 101–4, cat. 112; Kanter, in Timken Museum of Art, p. 32.

67. Meiss, "Notes on Three Linked Sienese Styles" (as in n. 21), p. 48; Van Os, *Sienese Paintings in Holland* (Groningen, 1969), no. 25; Fehm, *Luca di Tommè*, p. 36 n. 28; Van der Heide, in Van Os, *The Early Sienese Paintings* (as in n. 55), pp. 107–9, cat. 26; Roland Krischel, in *Lust und Verlust: Kolner Sammler zwischen Trikolore und Preussenadler,* exh. cat., Josef-Haubrich-Kunsthalle (Cologne, 1995), p. 582, cat. 190. It should be noted that while accepting the attribution to the Magdalen Master, Boskovits (*Early Italian Panel Paintings in Hungarian Museums* [Budapest, 1966], cat. 36) identified the personality of this artist as that of a precursor rather than a follower of Luca.

68. Freuler, *Master Paintings*, pp. 9–14.

69. Francesco Santi, *Galleria Nazionale dell'Umbria: dipinti, sculture e oggetti d'arte di eta romanica e gotica* (Rome, 1969), pp. 100–101, cat. 80; Fehm, *Luca di Tommè*, pp. 44–46, 130–31, cat. 39. Fehm's suggestion that this polyptych be identified with the St. Paul altarpiece fails to convince, especially since this work, as the author himself notes, cannot be connected, on a technical basis alone, with the St. Paul predella.

70. Fehm, *Luca di Tommè*, p. 166, cat. 66.

71. Susan L. Caroselli et al., *Italian Panel Painting of the Early Renaissance in the Collection of the Los Angeles County Museum of Art,* exh. cat., Los Angeles County Museum of Art (Los Angeles, 1994), pp. 51, 98–99, cat. 7, with previous bibliography.

72. Antonio Boschetto, *La collezione Roberto Longhi* (Florence, 1971), p. 5. Although rejected by Fehm, who considers the panels products of Luca's workshop (*Luca di Tommè*, pp. 26, 35 n. 21, 151–53, cats. 52–54), Longhi's original attribution has been accepted by most scholars. See De Benedictis, *La pittura senese,* pp. 48, 67 n. 80, 87–88; S. D'Argenio, in *La Fondazione Roberto Longhi a Firenze* (Milan, 1980), p. 242; Chelazzi Dini, in *Il gotico a Siena,* p. 278, no. 103; Milan, Finarte, *Dipinti antichi* (December 13, 1989), p. 104, lot 137. The association proposed by D'Argenio and Chelazzi Dini between these panels and a predella fragment in the Yale University Art Gallery (acc. no. 1943.246) is not convincing on both stylistic and technical grounds.

73. Zeri's reconstruction, proposed in oral communication, was first cited by De Benedictis, *La pittura senese,* p. 67 n. 80.

74. Skaug, *Punch Marks* (as in n. 4), vol. 1, p. 241 n. 107; vol. 2, charts 7.4, 7.10, punch no. 723. The only other artist besides Ambrogio and Niccolò to have employed this tool, according to Skaug, was Guiduccio Palmerucci, a contemporary of the Lorenzetti.

75. For a general discussion of the phenomenon of *compagnie* see Skaug, *Punch Marks,* vol. 1, pp. 310–19, with previous bibliography. Skaug's theory that this *compagnia* involved the added participation of artists as diverse as Bartolomeo Bulgarini, Naddo Ceccarelli, and Jacopo di Mino del Pellicciaio is not entirely convincing, however.

76. Fehm, *Luca di Tommè,* p. 19.

77. See note 14 above.

78. Federico Zeri and Elizabeth E. Gardner, *Italian Paintings: A Catalogue of the Collection of the Metropolitan Museum of Art: Sienese and Central Italian Schools* (New York, 1980), pp. 32–33.

79. Fehm, *Luca di Tommè,* pp. 24, 84, cat. 14.

80. On the basis of technical evidence alone, Skaug places the execution of the New York *Madonna* before the 1362 altarpiece. *Punch Marks,* vol. 1, pp. 246–47.

81. Except where noted all known documents are listed by Ettore Romagnoli, *Biografia cronologica de' bell'artisti senesi,* 13 vols. (Siena, 1835), vol. 3, pp. 409–10, and Milanesi, *Documenti per la storia dell'arte senese* (as in n. 24), vol. 1, pp. 31–32.

82. Gaudenz Freuler, *Bartolo di Fredi Cini: Ein Beitrag zur sienischen Malerei des 14. Jahrhunderts* (Disentis, 1994), p. 420, doc. 29.

83. See Kanter, in Timken Museum of Art (as in n. 14), p. 46, and note 14 above.

84. M. H. Laurent, *I necrologi di San Domenico in Camporegio: fontes Vitae S. Catherinae Senensis Historici,* Anno 15 (1937): 148 (2317).

85. Milanesi, *Documenti per la storia dell'arte senese,* vol. 1, pp. 31–32. Romagnoli also records having seen these panels in the same church in 1822, although he misread the signature as *Nicholaus de Jacobus de Senis.* Romagnoli, *Biografia cronologica,* vol. 3, pp. 295–96, 410; *Cenni storico-artistici di Siena e suoi suburbi* (Siena, 1840; Bologna, 1990), p. 98; Giuseppe Merlotti, *Memorie storiche delle parrocchie suburbane della diocesi di Siena* (Siena, 1881), ed. Mino Marchetti (Siena, 1995), p. 282.

86. Francesco Brogi, *Inventario generale degli oggetti d'arte della provincia di Siena (1862–65)* (Siena, 1897), pp. 190–91; Roberto Guerrini et al., *Siena, le Masse: il Terzo di Citta* (Siena, 1994), pp. 107–8.

87. For the National Gallery panel, see Dillian Gordon, *National Gallery Catalogues: The Early Italian Schools before 1400* (London, 1988), pp. 86–88; Jill Dunkerton et al., *Giotto to Dürer: Early Renaissance Painting in the National Gallery* (London, 1991), pp. 230–31, cat. 8; Christopher Baker and Tom Henry, *The National Gallery: Complete Illustrated Catalogue* (London, 1995), p. 503. For the Uffizi panel, see Marcucci, *Gallerie Nazionali di Firenze* (as in n. 34), p. 169; Luciano Bellosi, *Gli Uffizi: Catalogo generale* (Florence, 1979), p. 395. For the Lehman panel, see John Pope-Hennessy and Laurence B. Kanter, *Italian Paintings in the Robert Lehman Collection* (New York, 1987), pp. 33–35, cat. 14.

88. For a summary of the early literature, see Anne Marie Doré, in *L'art gothique siennois: enluminure, peinture, orfèvrerie, sculpture,* exh. cat., Avignon, Musée du Petit Palais (Florence, 1983), pp. 261–63.

89. Miklós Boskovits, "Su Niccolò di Buonaccorso, Benedetto di Bindo e la pittura senese di primo quattrocento," *Paragone,* 31, nos. 359–61 (1980): 4–5.

90. Pope-Hennessy and Kanter, *Italian Paintings in the Lehman Collection,* p. 33. The panel is published without attribution in Borgia et al., *Le biccherne* (as in n. 44), p. 116.

91. See most recently Miklós Boskovits, *Gemäldegalerie Berlin, Katalog der Gemälde: Frühe italienische Malerei* (Berlin, 1988), p. 140; and Freuler, *"Manifestatori delle cose miracolose"* (as in n. 21), p. 69.

92. Cesare Brandi, "Niccolò di Buonaccorso," in *Allgemeines Lexikon der Bildenden Kunstler,* ed. Thieme-Becker (Leipzig, 1931), vol. 25, pp. 431–32; Pope-Hennessy and Kanter, *Italian Paintings in the Lehman Collection,* p. 33; Kanter, *Italian Paintings in the Museum of Fine Arts* (as in n. 39), p. 21, and in Timken Museum of Art, p. 46.

93. Romagnoli, *Biografia cronologica,* vol. 2, pp. 657–60; Milanesi, *Documenti per la storia dell'arte senese* (as in n. 24), vol. 1, 1854, p. 50.

94. Buonaccorso was buried on June 7, 1363 (one week before Niccolò di Ser Sozzo); one son, not mentioned by name, on July 18, 1363; and another son, Pace ("Pace filius Bonaccursi pictoris"), on August 21, 1363. Laurent, *I necrologi* (as in n. 84), pp. 94 (1226), 97 (1300), 98 (1346). Romagnoli, *Biografia cronologica,* vol. 2, p. 659, probably confused the references to father and son and mistakenly reported August 21 as the date of Buonaccorso's death.

95. The suggestion that Jacopo di Mino had a central role in the formation of a generation of Sienese painters that included, along with Niccolò di Buonaccorso, Francesco di Vannuccio, Bartolo di Fredi, Andrea Vanni, and Paolo di Giovanni Fei, was first made by Luciano Bellosi, "Jacopo di Mino del Pellicciaio," *Bollettino d'arte* 57 (1972): 73–77. See also Boskovits, "Su Niccolò di Buonaccorso," p. 4; Doré, *L'art gothique siennois*, p. 261; Kanter, *Italian Paintings in the Museum of Fine Arts*, p. 106, and in Timken Museum of Art, p. 46.

96. For the suggestion that Naddo Ceccarelli might actually have collaborated with Jacopo di Mino in the 1340s, see Skaug, *Punch Marks*, vol. 1, p. 239.

97. Pope-Hennessy and Kanter, *Italian Paintings in the Lehman Collection*, p. 33. For the original form of the Orsini polyptych, presently divided between Antwerp, Berlin, and Paris, see Andrew Martindale, *Simone Martini* (New York, 1988), pp. 171–73, cat. 2, with previous bibliography.

98. See Keith Christiansen, "Simone Martini's Altarpiece for the Comune of Siena," *Burlington Magazine* 136, no. 1092 (March 1994): 148–60. I am grateful to Laurence Kanter for this suggestion.

99. Marcucci, *Gallerie Nazionali di Firenze* (as in n. 34), p. 169.

100. Daniela Gallavotti Cavallero, "Pietro, Ambrogio e Simone, 1335, e una questione di affreschi perduti," *Prospettiva* 48 (1987): 69–74; Keith Christiansen, in *Painting in Renaissance Siena, 1420–1500* (New York, 1988), pp. 146–51.

101. Meiss, *Painting in Florence and Siena*, p. 43 n. 124.

102. Pope-Hennessy and Kanter, *Italian Paintings in the Lehman Collection*, p. 35.

103. Kanter, in Timken Museum of Art, pp. 46–51, with previous bibliography.

104. Doré, *L'art gothique siennois*, pp. 262–63.

105. Meiss, *Painting in Florence and Siena*, p. 134 n. 7. As noted by Meiss and Kanter (in Timken Museum of Art, p. 50), similar details are included in a Holy Family, possibly by Ambrogio Lorenzetti in the Abegg collection, Riggisberg. Illustrated in Freuler, *"Manifestatori delle cose miracolose,"* p. 292, no. 28.

106. Henk van Os, "Mary as Seamstress," reprinted in *Studies in Early Tuscan Painting* (London, 1992), pp. 277–86; Doré, *L'art gothique siennois*, p. 262; Kanter, in Timken Museum of Art, p. 50.

107. Torriti, *La Pinacoteca Nazionale di Siena* (as in n. 20), p. 551, no. 222, catalogued it as "unknown Sienese master close to Niccolò," and cited Zeri's attribution to the Master of Panzano. Kanter, *Italian Paintings in the Museum of Fine Arts*, p. 106, correctly ascribes the panel to Niccolò, although his suggestion that it might originally have formed part of the same diptych as a *Crucifixion* by Niccolò formerly in the Toscanelli collection, now in the Chiaramonte Bordonaro Collection, Palermo, is not entirely convincing.

108. The Munich panels were first attributed to Niccolò by Boskovits, "Su Niccolò di Buonaccorso," p. 6 n. 16, who, however, situated their execution in the last decade of the artist's career. They are considered early works and rightly related to the Timken triptych by Kanter, in Timken Museum of Art, p. 48.

109. Formerly in the museum at Gotha, this panel was first attributed to Niccolò by Meiss, *Painting in Florence and Siena*, p. 171 n. 23. Boskovits, who does not seem to have known of Meiss's attribution, "Su Niccolò di Buonaccorso," pp. 6–7 n. 18, published it unconvincingly among Niccolò's late works.

110. The present location of this painting, sold on the art market in 1987, remains unknown. It was recognized as a work of Niccolò as early as 1931, during restorations carried out under Cesare Gnudi and Peleo Bacci. See Alessandro Leoncini, *I tabernacoli di Siena, arte e devozione popolare* (Siena, 1994), p. 148, with previous bibliography.

111. Bruce Cole and Adelheid Medicus Gealt, "A New Triptych by Niccolò di Buonaccorso and a Problem," *Burlington Magazine* 119, no. 888 (March 1978): 184–87. For comments on this article, see Kanter, in Timken Museum of Art (as in n. 14), p. 51 n. 2.

112. Torriti, *La Pinacoteca Nazionale di Siena*, p. 94, no. 121.

113. For the use of such model books in trecento Siena, see Hayden B. J. Maginnis, "The Craftsman's Genius: Painters, Patrons, and Drawings in Trecento Siena," in *The Craft of Art: Originality and Industry in the Italian Renaissance and Baroque Workshop*, ed. Andrew Ladis and Carolyn Wood (Athens and London, 1995), pp. 25–47.

114. Boskovits, "Su Niccolò di Buonaccorso," p. 5 n. 11, with previous bibliography.

115. Freuler, *"Manifestatori delle cose miracolose,"* p. 70; *Bartolo di Fredi Cini* (as in n. 82), pp. 317, 461–63, cat. 39. The affinities discernible between Niccolò's and Bartolo di Fredi's idiom led Boskovits ("Su Niccolò di Buonaccorso," pp. 5–6 n. 13), followed by Freuler (*"Manifestatori delle cose miracolose,"* p. 70), to mistakenly reattribute to Niccolò and to associate with the Costalpino altarpiece a predella fragment with the *Presentation of the Virgin in the Temple* formerly in the Kaulbach collection, Munich, and now in the Honolulu Academy of Arts (no. 3042), correctly attributed to Bartolo di Fredi or his workshop by Federico Zeri, "Honolulu Academy of Arts: Seven Centuries of Italian Art," *Apollo* (February 1979): 88. A second predella fragment associated by Boskovits with the Costalpino altarpiece, a *Crucifixion* in the Museum of Fine Arts, Budapest (no. 17)—previously attributed by the same author to Bartolo di Fredi's workshop (Boskovits, *Early Italian Panel Paintings in Hungarian Museums* [as in n. 67], no. 39)—appears rather to be a product of the same hand that executed a triptych in the Pinacoteca Nazionale, Siena (no. 137). This work is given by Torriti to Paolo di Giovanni Fei (*La Pinacoteca Nazionale di Siena*, pp. 125–27), but was more likely executed by a follower or member of his shop (Michael Mallory, *Paolo di Giovanni Fei (c. 1345–1411)* (New York, 1976), p. 213.

116. Girolamo Gigli, *Diario senese*, 3 vols. (Siena, 1854; Bologna, 1974), vol. 2, pp. 33–35; Merlotti, *Memorie storiche* (as in n. 85), pp. 490–91.

117. Emanuele Repetti, *Dizionario geografico fisico storico della Toscana*, 6 vols. (Florence, 1833–46), vol. 3, p. 367; Merlotti, *Memorie storiche*, pp. 279–82.

118. Merlotti, *Memorie storiche*, p. 282.

119. Miklós Boskovits, "Il gotico senese rivisitato: proposte e commenti su una mostra," *Arte Cristiana* 71 (1983): 274 n. 36. The painting had previously been catalogued by Zeri and Gardner, *Italian Paintings of the Metropolitan* (as in n. 78), pp. 13–14, as a work of Francesco di Vannuccio. Boskovits's attribution has been accepted by subsequent scholars: Freuler, *"Manifestatori delle cose miracolose"* (as in n. 21), p. 70; Katherine Baetjer, *European Paintings in the Metropolitan Museum of Art, by Artists Born before 1865: A Summmary Catalogue* (New York, 1995), p. 48.

120. Usually referred to as by Bartolo di Fredi, the Frankfurt *Madonna* was first correctly attributed to Niccolò by Boskovits, "Su Niccolò di Buonaccorso" (as in n. 89), p. 6 n. 17. However, Boskovits supposed it to have formed part of the same polyptych as the Glasgow St. Lawrence, that is here considered instead an earlier work.

121. Kanter, *Italian Paintings in the Museum of Fine Arts,* pp. 106–7.

122. Doré, *L'art gothique siennois,* pp. 262–63.

123. Millard Meiss, "Italian Primitives at Konopiste," *Art Bulletin* 28, no. 1 (March 1946): 5; Kanter, *Italian Paintings in the Museum of Fine Arts,* p. 106. The same version of this composition is also found in a much repainted triptych formerly in the Cyrus McCormick collection, Chicago, now in a private collection.

124. Boskovits, *Gemäldegalerie Berlin* (as in n. 91), pp. 141–42, no. 56.

125. Federico Zeri, review of P. Torriti, *La Pinacoteca Nazionale di Siena: I dipinti dal XII al XV secolo,* in *Antologia di belle Arti* 6 (1978): 151; Boskovits, "Su Niccolò di Buonaccorso," p. 6 n. 15; Doré, *L'art gothique siennois,* p. 262; Boskovits, *Gemäldegalerie Berlin,* p. 140.

126. Bernard Berenson, "Homeless Paintings of the Sienese Trecento," *International Studio* (1930–31), reprinted in *Homeless Paintings of the Renaissance* (Bloomington, Ind., 1970), p. 39. Berenson's attribution to a follower of Niccolò, it should be noted, referred only to the Hartford picture, which at this date had not yet been associated with the panel in New York. The identification of the two images as part of a single complex executed by Niccolò's workshop was first made by Hayden B. J. Maginnis, "The Literature of Sienese Trecento Painting, 1945–1975," *Zeitschrift für Kunstgeschichte* 40 (1977): 299. See also Pope-Hennessy and Kanter, *Italian Paintings in the Lehman Collection* (as in n. 87), pp. 36–37, no. 15; and Jean K. Cadogan, *Wadsworth Atheneum Paintings, II: Italy and Spain, Fourteenth through Nineteenth Centuries* (Hartford, Conn., 1991), pp. 68–70, with previous bibliography.

127. Meiss, *Painting in Florence and Siena,* pp. 22 n. 30, 122 n. 69. For the attribution of the panel in Siena directly to Niccolò, see Torriti, *La Pinacoteca Nazionale di Siena,* pp. 95–96, no. 163, with previous bibliography.

128. Berenson, "Homeless Paintings," pp. 43–47. Federico Zeri, *Italian Paintings in the Walters Art Gallery* (Baltimore, 1976), pp. 46–47; Luciano Cateni, in *La sede storica del Monte dei Paschi di Siena: Vicende costruttive e opere d'arte,* ed. Francesco Gurrieri et al. (Siena, 1988), pp. 270–73.

129. Bernard Berenson, *Italian Pictures of the Renaissance: Central and North Italian Schools,* 2 vols. (London, 1968), vol. 1, pp. 254–55. The date of the Montalcino altarpiece, recorded in a partially legible, ruined inscription at the base of the panel, has also been reported as 1382. See below.

130. Sherwood A. Fehm, "Luca di Tommè's Influence on Three Sienese Masters: The Master of the Magdalen Legend, the Master of the Panzano Triptych, and the Master of the Pieta," *Mitteilungen des Kunsthistorisches Institutes in Florenz* 20 (1976): 338–47.

131. Denise Boucher de Lapparent, "Le Maître de Panzano," *Revue du Louvre* 28 (1978): 165–74.

132. Gordon Moran, "Un'ipotesi circa l'identificazine del Maestro di Panzano," *Il Gallo Nero,* no. 1 (1978): 10–13.

133. The St. Nicholas of Tolentino was mistakenly identified by Berenson, "Homeless Paintings," pp. 44–45, as a St. Anthony of Padua.

134. Fehm, "Luca di Tommè's Influence," pp. 341–45.

135. Fehm, *Luca di Tommè* (as in n. 7), pp. 102–3, cat. 24.

136. First attributed to the workshop of the artist by Fehm, "Luca di Tommè's Influence," pp. 345–46, this work has been situated in an early phase of the artist's career, about 1350–60, by Serena Padovani, in *Mostra di opere d'arte restaurate nelle province di Siena e Grosseto, II,* exh. cat., Siena, Pinacoteca Nazionale (Genoa, 1981), pp. 44–45, no. 10. See, however, Cateni, *La sede storica del Monte dei Paschi,* p. 272, for the suggestion that such a dating might be too precocious.

137. Federico Zeri, *La collezione Federico Mason Perkins* (Turin, 1988), pp. 64–67, no. 21.

138. Freuler, *Bartolo di Fredi Cini* (as in n. 82), p. 467, cat. 44.

139. Ibid., pp. 188–221, 469–76, cats. 48–59. Datable to the same moment in the artist's career, near the Montalcino altarpiece, are also a little-known triptych in a private collection, France (Carlo Volpe, in *Gold Backs, 1250–1480,* exh. cat., Matthiesen Fine Art Ltd. [London, 1996], pp. 81–84, cat. 10), as well as a panel of a Madonna and Child with eight saints first published by Berenson ("Homeless Paintings" [as in n. 127], p. 45, fig. 642) and most recently on the art market in New York (Sotheby's, June 5, 1986. See Mauro Natale, *Pittura italiana dal '300 al '500* [Milan, 1991], p. 174).

140. Berenson, "Homeless Paintings," p. 65. The attribution was rejected by Boucher de Lapparent, "Le Maître de Panzano," p. 174 n. 12. It was first recognized as part of Bartolo's *Coronation of the Virgin* by Freuler. See Freuler, *Bartolo di Fredi Cini,* p. 475, cat. 57, with previous bibliography.

141. Boucher de Lapparent, "Le Maître de Panzano," fig. 1.

142. Wolfgang Fritz Volbach, *Catalogo della Pinacoteca Vaticana,* vol. 2, *Il trecento, Firenze e Siena* (Vatican City, 1987), p. 50, no. 61, with previous bibliography; Boucher de Lapparent, "Le Maître de Panzano," p. 170; and Boskovits, "Su Niccolò di Buonaccorso," p. 16.

143. Originally attributed to Paolo di Giovanni Fei (Julia Gethman Andrews, *The Fine Arts Gallery, San Diego: A Catalogue of European Paintings, 1300–1870* [San Diego, 1947], p. 25; Berenson, *Central and North Italian Schools,* p. 129), the San Diego panels were first associated with the Panzano Master by Burton B. Fredericksen and Federico Zeri, *Census of Pre-Nineteenth-Century Italian Paintings in North American Public Collections* (Cambridge, Mass., 1972). It is included among the works of this artist by Fehm, "Luca di Tommè's Influence," p. 340 n. 9, and Boucher de Lapparent, "Le Maître de Panzano," pp. 171, 174 n. 25.

144. Ibid., pp. 171, 174 n. 27.

145. Though consistently attributed to Niccolò di Buonaccorso in the past, the Houston predella—which shares with the Berlin panel the distinctive use of a five-petaled rosette punch in the figures' haloes, rather than the circular punch more usually employed by the artist—is inexplicably rejected from his oeuvre in the museum's recent catalogue. Carolyn C. Wilson, *Italian Paintings, XIV–XVI Centuries, in the Museum of Fine Arts, Houston* (Houston, 1996), pp. 42–50, cat. 3, with previous bibliography.

146. Fehm, *Luca di Tommè,* pp. 198–99, docs. 19a and 19b.

147. The possibility of such a situation, in which Paolo di Buonaccorso would have been called on to complete Niccolò's unfinished commissions, is suggested by the documented case, in the fifteenth century, of Sano di Pietro's taking over the execution of works begun by Sassetta, after the latter's sudden death. See Alexandra Pietrasanta, "A 'lavorii rimasti' by Stefano di Giovanni called Sassetta," *Connoisseur* 177 (June 1971): 95–99; Torriti, *La Pinacoteca Nazionale di Siena,* pp. 195–96.